ORANGE COUNTY

ORANGE COUNTY

Introduction by
Ray Bradbury

Photography by
Bill Ross
Ralph Starkweather
West Light

SKYLINE
PRESS

Produced by Boulton Publishing Services, Inc., Toronto
Designed by Fortunato Aglialoro

© 1985 Oxford University Press (Canadian Branch)
SKYLINE PRESS is a registered imprint of the Oxford University Press

ISBN 0-19-540624—9
1 2 3 4 - 8 7 6 5
Printed in Hong Kong by Scanner Art Services, Inc., Toronto

BIG ORANGE, *SI!*
BIG APPLE, *NO!*

an essay by Ray Bradbury

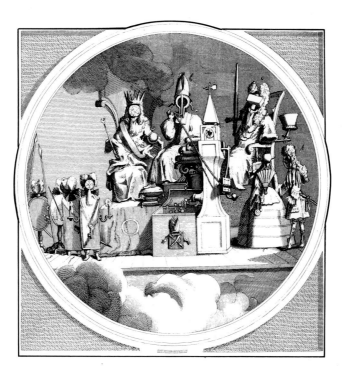

Robert Benchley once wrote that there are two kinds of travel: First Class, and with children.

To which I add, there is only one direction to travel in the United States:
West.

And, when you get there:
South.

Into a land where dawn lingers its pink clouds, and sunset prolongs its horizon with tangerine hues that would tempt film director David Lean to run his cinema cameras overtime.

For it was David Lean, you recall, who waited before breakfast, and just after late teas, for those glorious illuminations that arrive only at sunrise or twilight, to cloak actors in bronze, armour their plain jackets with the light of nations, and powder their brows with enough gold to make Rameses fresh from the tomb look like John Travolta.

Lean could have saved himself all that terrible waiting. There is a place in California where it is always sunrise Tangee pink and nectarine sunset glow.

Or so its inhabitants claim.

Color it Orange County.

And lest this sound like the introductory remarks to Project Overkill, let me sprint on across the hot, Lawrence-of-Arabia dunes to land you at Newport Beach's John Wayne airport, where the deer and the antelope played only a few thousand days ago, before the farmers, real-estate swifties, and Cessna pilots buzzed them off.

Here, between Highway 10 heading south to Nowhere, or Baja California, whichever comes first, is a landgrab territory, ten to fifteen miles in circumference, part new-tract-housing, part tilled-farmland, part science-fiction dump-site for AD 1999.

Motoring through, you expect to find and do find those huge yellow-beetle machines that chew and shove earth around so as to plant Tomorrow.

And further, you expect to happen upon great Japanese Christmas-toy robots fetching that Tomorrow in Orange-County-bright packets which, dropped into this ripe soil, burgeon up in harvests of new, newer, newest.

For everything *is* new here, or almost everything. Industrial parks, planned towns, spanking brand-new Grecian and Roman-forum shopping-malls.

Plus castles made of surfboards, from which hang-gliding high-school teachers and college professors launch themselves down along the shores to surprise-assault their bleached, burned and vagrant students. There they force said children to tote water-proofed texts into the seas and down the sands, so as to educate themselves while surfing or dune-buggying.

The professors, needless to say, are followed by yet other assault-troops of parachuting priests, ministers, and an occasional

(above) William Hogarth: *Some of ye principal inhabitants of ye Moon, as they were perfectly discovered by a telescope brought to ye greatest perfection since ye last eclipse.* 1724.

Unitarian rabbi, shouting forgiveness from the sky, and proffering holy biscuits and Last Supper BINGO pizzas along the surfline.

For if Orange County is not the land of forever summer, it most certainly is Forgotten Winter, California, where December never comes and Santa Claus arrives in a helicopter and a bikini-tux.

It is, then, the territory of honorable buns, hot-dog and derrière, and the Nordic hair, and the peeling skin. Graduation Day at Newport Harbor High looks like a flock of Mormon Tabernacle choirfolk. How soon the real world of blacks waiting out beyond will infiltrate, no one knows. The nearest thing to genetic color is a splash of Hispanics here and there. The rest is the June, July, and August tint of diet-firm bottoms forever sunflower-turned to follow the hours.

The clichés about Orange County abound. Shake it upside down and a shower of Barry Goldwater clones rains forth. Scan it sidewise and it is a mere Flatland of reactionary conservatives. Run barefoot over it at your liberal peril—it is a Republican hotbed. Doonesbury would starve here. It is the bin where old razorblades go to die. It is a secret Australian colony. It is Johannesburg West. It is . . .

Enough.

None, I repeat NONE, of the above things is true.

Sure, in many of its schools the only idea of darkness is the Beach Boys fresh from the shore, colored seven shades of sunlight, and not having to be bussed anywhere.

But a lot of California shares this love of heat, light and the endless summers that burn California brown to make it, conversely, green at Christmas. Most of us are cousins to the sunbaked tortoise or the surf-crab that, when tossed upshore, whirls about with photoflash instinct and heads for the sea.

In the midst of which California and Orange County are changing the future of the entire USA. From here, with Walt Disney as prime father, the cities and malls of 2001 are being dreamed, shaped and built. Because of what started here 30 years ago, 250 million Americans will live better in Gumball, Minnesota, Mishapewoc, Wisconsin, and East Orange, New Jersey, which is no kind of Orange at all.

If California is going to run the country, aesthetically, culturally, politically, scientifically, and otherwise, on through the 21st Century, a lot of the spinal-cord nerve-endings will be plugged into Santa Ana, Newport Beach, and the Irvine Company here.

So *much* from so very *little*.

For to see Knott's Berry Farm here today is to recall, for those of us who were once very young fifty years ago, a ramshackle collection of outbuildings where berry pies were served with fresh coffee, and the single-attraction Ghost Town sported an old, stuffed, wax-mannequin miner. He sprawled in an empty room, seemingly asleep. If you peeked in his door, he made rude comments to you with a hidden radio-actor's voice.

Little did we realize, five decades back, that from such Spartan entertainments Disney's robots would leap forth in wonders to stride the world and provoke new generations to rebuild their souls and then their towns.

Which brings us to another cliché.

Everybody has made fun of the Crystal, or as it is sometimes known, 'Memorex' Cathedral. If the great 200-inch telescope at Palomar just down the coast is a glass eye on the Universe, then the Cathedral is a multi-thousand-paned kaleidoscope, hung on the California sky in architectures and alive with hymns.

Target of critics, those bad boys who live in glass houses and throw gallstones, the Cathedral nevertheless works, by gum, as a thing of beauty and a joy—if you have your name-plate nailed to a pew—forever.

Its acoustics (one *reads* because *hearing* is a trifle difficult) are always in transit. Whether or not the sound problems can be solved by putting dark sunglass-buffers on the ten thousand panes is still in debate. One thing is sure, it is a grand lesson in optimism to rear such a greenhouse-for-humans on Earthquake acreage. Adding that there is no truth to the rumor that the Catholics have leased the San Andreas fault and plan to run it south to the Cathedral's wine cellar.

So here you have a book of pictures, already colored, where you can look and find Tomorrow always arriving.

If California in the Thirties was Mecca II and Riviera Acres to the Oakies dusting their way west, today Newport, Laguna, and all the fresh-squeezed towns clustered near are concentrated 2001 citrus juice, 100 percent sunstroke-pure.

As long as the continent tilts away from snow and the dead-iron ghost-towns of the upper mid-west, the long population slide will continue to land in heaps amidst the sandcastles and high-tech industries of this O-beautiful-for-spacious-sky-country.

And when Orange County runs out of land, you sense that these once-orchard farmers will Sahara sandhose the dunes and shove the shoreline out an extra mile or so to replenish the land. Where God took some few million years to describe this coast, the real-estate craftsmen with their sandhoses spouting desert earths will, like Moses, push back the sea, raise fresh land values, and incorporate as 'New Terra Firma, California'.

There, a century or so from now, with surfboards for tomb-stones, the cemeteries will be planted with populations of 150-year-old Beach Boys, their skins, in rigor mortis, as dark bright as new-minted pennies, their dinghy-row-boat coffins marked 'HANG TEN'.

The Brave New Future, in sum, full of such men as would make a real-estate salesman's mouth pump oil, and cause New Yorkers to wake in midwinter blizzards at three in the morning, shrieking for airline tickets and packing their wetsuits in the dark.

Will Orange County go on growing forever?

Yep.

Or until they run out of borrowed hourglass-sand or have to jog next door to Mexico to borrow a cup of sun.

Or the Governor builds a stop-moat at the Arizona border to keep out the crazed grapefruits, or tosses up Star Wars artillery to knock down the immigrant lemmings from No Thaw, Nebraska.

By the year 2210, Orange County will probably peninsula out halfway to Oahu and nigh on to heaven. There, in Tarbaby, California, whose motto is 'Once you Touch Us, You Can't Get Away', the ancient molasses-colored people, furnaced by the years, will never leave Shangri La's Disneyport for fear of turning to papyrus and blowing away in epidermal confettis.

Would I lie to you?

Los Angeles, November 1984 RAY BRADBURY

1 *(right)* Newport Beach.

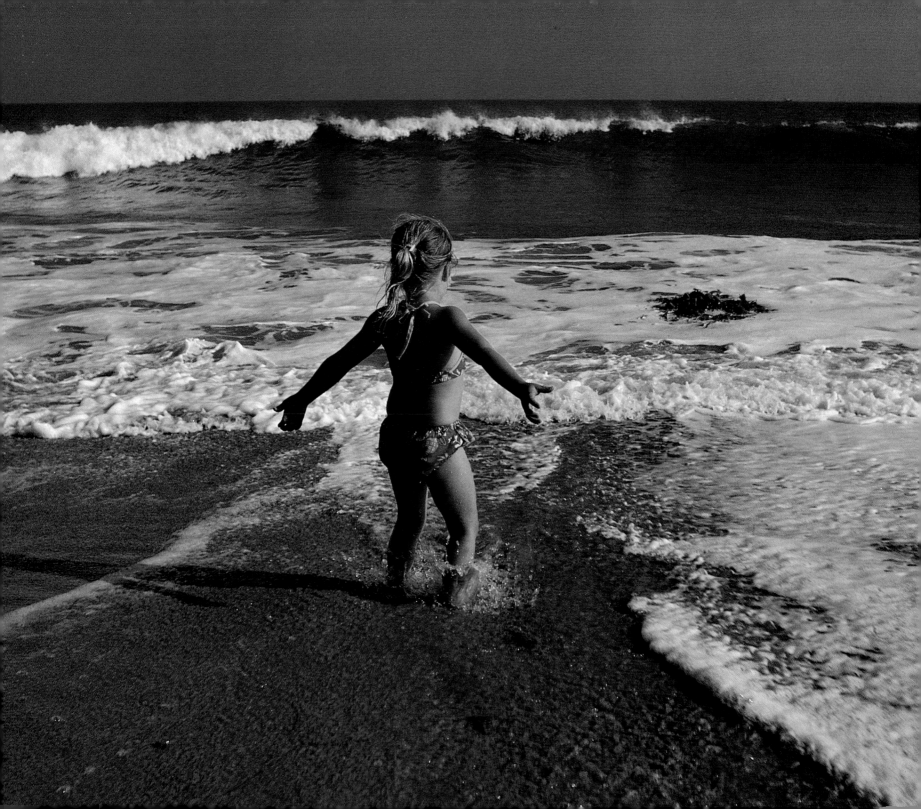

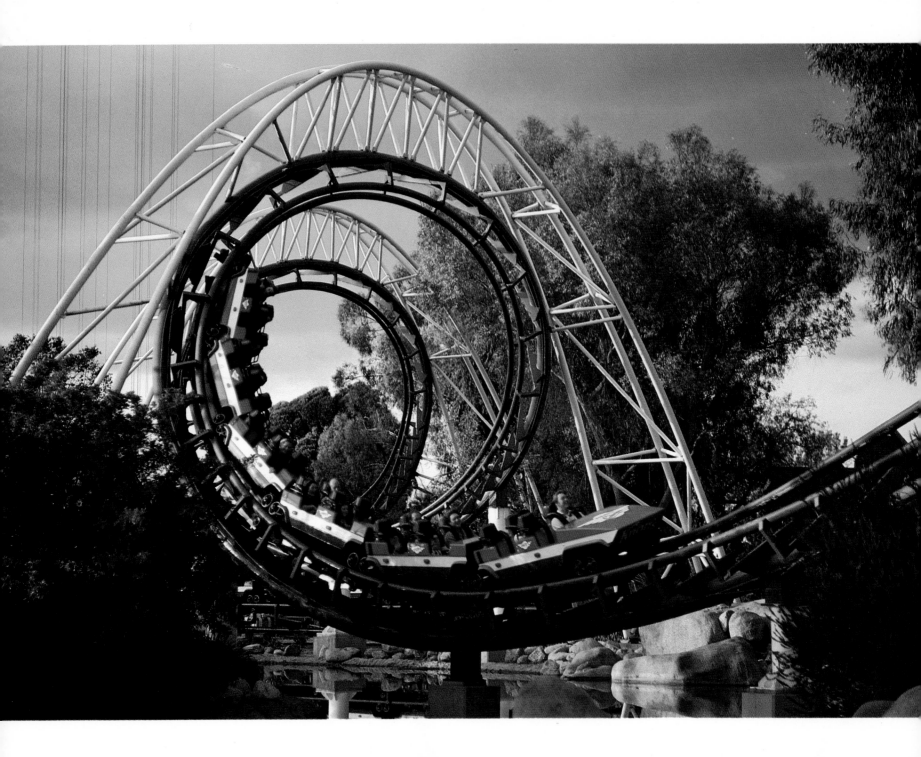

2 *(left)* The Corkscrew Roller-Coaster Ride in the 'Roaring Twenties' section of Knott's Berry Farm, Buena Park. The world's first upside-down and double-looped roller-coaster with two 360° loops.

3 Merry-go-round, Knott's Berry Farm. It all began because Mrs Cordelia Knott's chicken dinners were irresistibly good. When the Depression came to their berry-patch Cordelia and Walter Knott started selling pies and preserves at roadside-stalls, then chicken dinners, and soon had line-ups so long that Walter built a 'Ghost Town' to entertain the waiting customers. The Ghost Town is still there, authentic buildings, with a Mine and a Railroad, and now there's also 'Fiesta Village', that recreates the early days of California and Mexico, as well as a roller-coaster called 'Montezooma's Revenge'. The third main area is the 'Roaring 20s Amusement Area and Airfield', with a parachute jump of 200 feet, the 'corkscrew' (see plate 2), the Good Times Theater, the Cloud 9 Dance Hall and a restaurant in an airplane hangar. From a 10-acre berry farm in 1920 has grown a theme park of 135 acres, with over 20 restaurants (one of them still serving chicken dinners—over a million a year) and a hundred attractions that bring five million people to the Farm every year. Only Disneyland and Disney World draw larger crowds. A day at Knott's Berry Farm, an evening there round the campfire, will leave a flavor in the memory that lingers for many years.

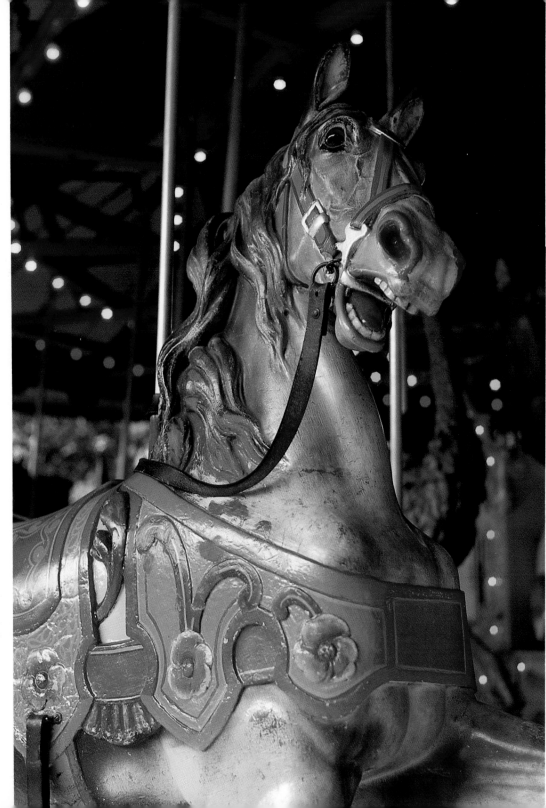

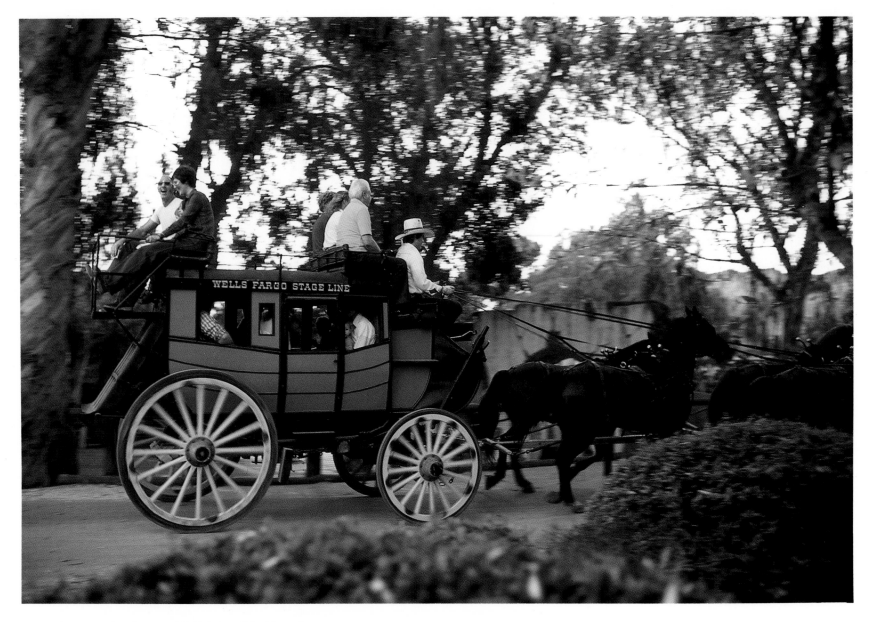

4 Bandits in Walter Knott's Old West will hold up the stage at every turn;
Knott's Berry Farm, Buena Vista Park.

5 *(right)* The Denver and Rio Grande Calico Railroad won't have much
better luck either; Knott's Berry Farm, Buena Vista Park.

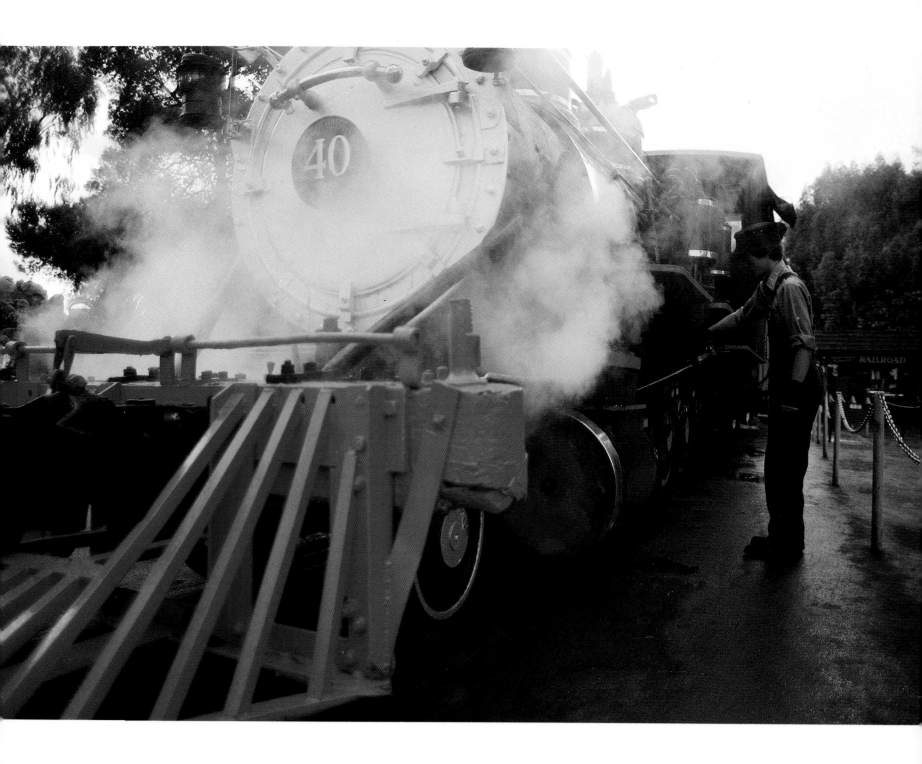

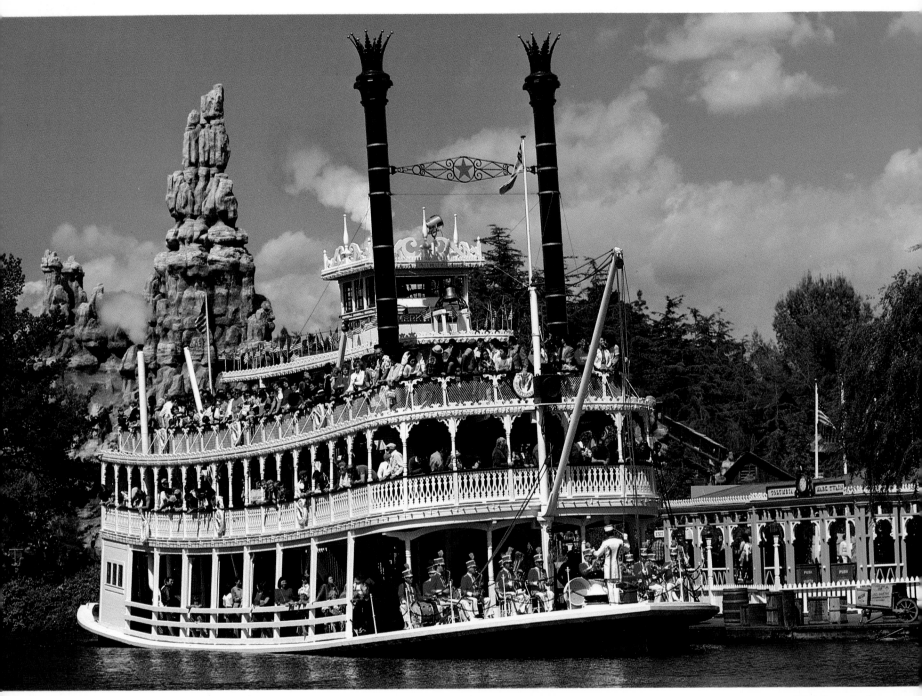

6 *(left)* The *Mark Twain*, a Mississippi stern-wheeler on the Rivers of America, in 'Frontierland', a land of dense wilderness, America in the rugged 1800s. 'Frontierland' is one of seven areas into which Disneyland, near Anaheim, is divided, these being: 'Main Street USA' (plate 7), a typical 'main drag' at the turn of the century, with horse-drawn wagons, buggies, nickelodeons and the like, and also the entrance to the entire park; 'Adventureland' with tours of the Amazon, Congo and Nile, the Jungle River Cruises, and the Swiss Family Robinson; 'Bear Country'—Davy Crockett Explorer Canoes and animated bears in the rugged outdoors; 'Fantasyland', dominated by sleeping Beauty's Castle (see plate 8); 'New Orleans Square', with Mardi Gras parades and Dixieland jazz, Pirates, and a Haunted House; and 'Tomorrowland' (see plate 9).

7 Parade down 'Main Street USA', Disneyland, Anaheim.

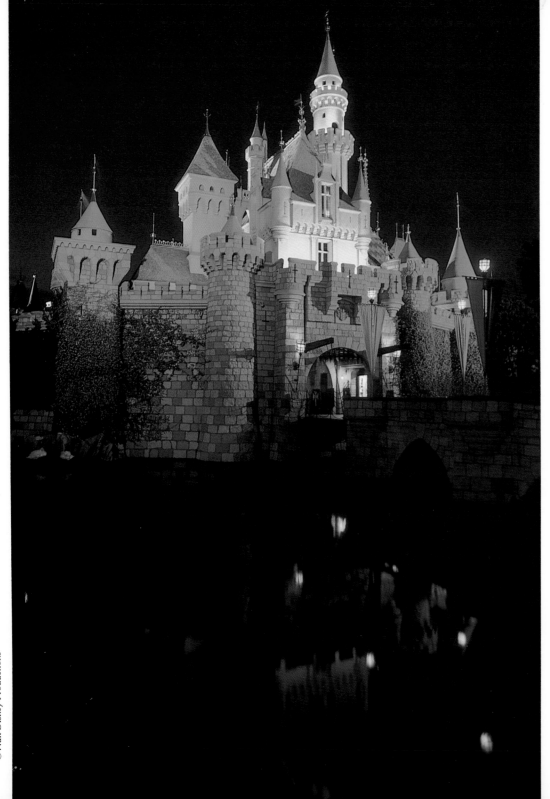

8 Sleeping Beauty's Castle, 'Fantasyland', perhaps the best-loved and most oft-photographed sight in all the Disneyland park. Opened on 160 acres in 1955 to immediate success, and since much enlarged, Disneyland was the brainchild of the late, great genius Walt Disney, who had the simple but visionary idea of combining the fun of an amusement park with the settings and fantasies of films. Although widely imitated elsewhere since, in America and abroad, Disneyland remains after thirty years the one and only supreme original, with well over eleven million visitors a year.

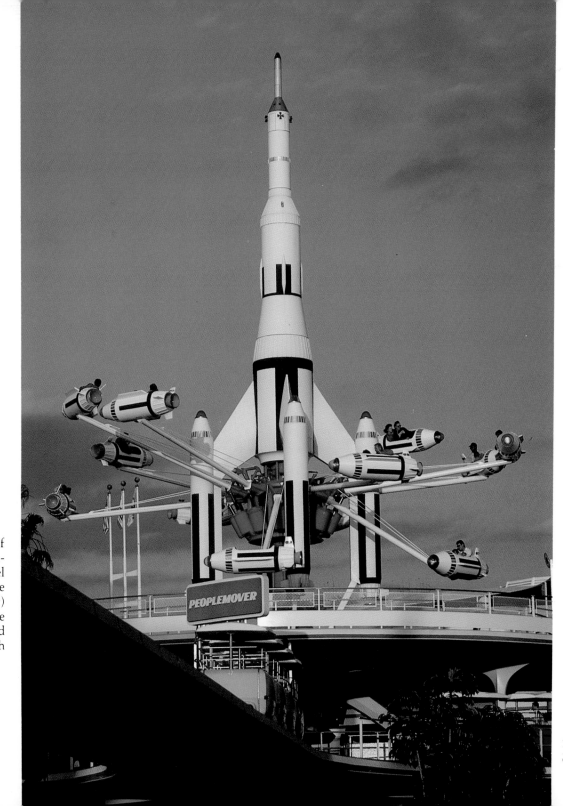

9 Rocket-ride, 'Tomorrowland', a part of Disneyland that probes into the future, constantly changing to keep up with space-travel and science. Here are the great Monorail, the Adventure through Inner (microscopic) Space, the Atomic Submarine Voyage, the Rocket to the Moon, a Mission to Mars, and Space Mountain, where a voyage through the cosmos begins.

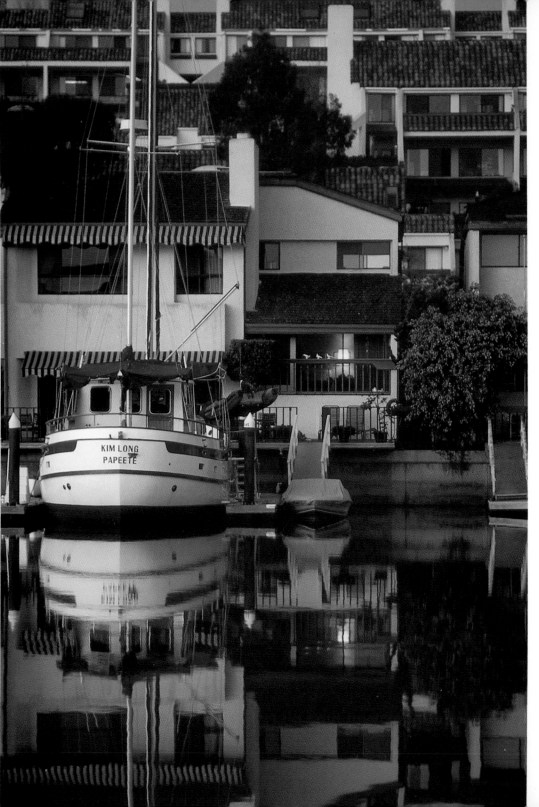

10 Newport Beach, where pleasure-boats dock at patio-wharves, and in the many marinas, and fill the harbor with one of the largest and wealthiest yacht populations in the world.

11 *(right)* Late afternoon light at Dana Point Harbor. The name commemorates Richard Henry Dana, Jr (1815-82), author of *Two Years Before the Mast*. Born to New England wealth and privilege, he was driven from his studies at Harvard by failing eyesight, the result of measles, to pursue an outdoor life, and signed on as a seaman to California in 1834. From these experiences came his classic book. In 1835 his ship the *Pilgrim*, a hide trader from Boston, was anchored off this headland when his mates threw down some bundles of cowhides that caught on the rockface. Dana rappelled down the cliff on a ship's rope and tossed out the hides to the beach below.

Dana Point is now a yachting resort where a harbor festival is held every February to celebrate the migrations of the gray whale.

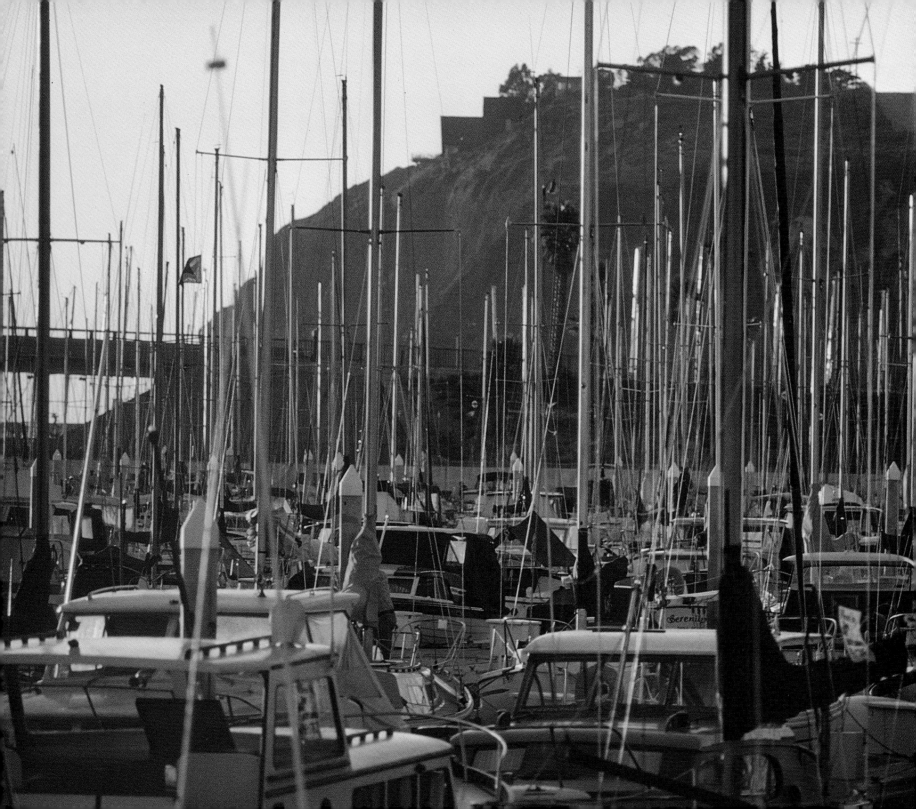

12 Mission of San Juan Capistrano, dedicated by Fra Junipero Serra in 1776; the first church was built a year later, the mission named after Saint Giovanni Capistrano (1386-1456) an Italian Franciscan friar and vicar-general. Earthquakes largely destroyed the mission buildings in 1812 and 1918. They have only partially been restored. The ruins have many beautiful associations, however—the church where Fra Serra celebrated Mass, the belfries to which the swallows return, the gardens that bloom year-round. Legend has it that the swallows leave their nests to fly off south on 23 October, the day that Giovanni died, and return faithfully on St Joseph's Day, 19 March, at the beginning of spring.

13 *(right)* Cloisters, San Juan Capistrano.

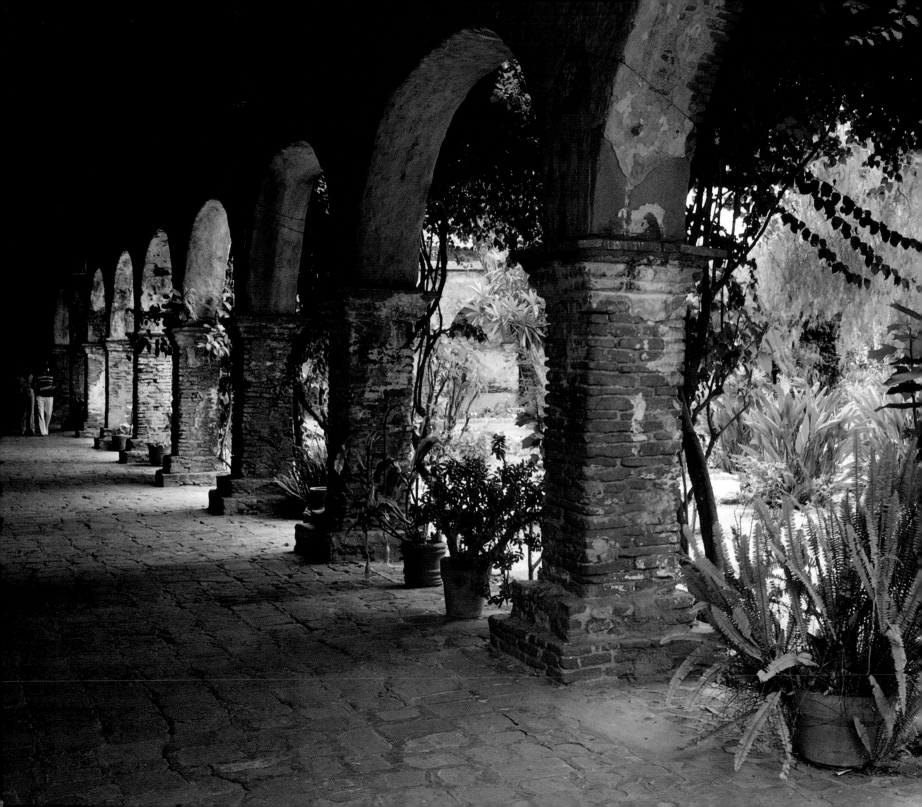

Sanctus Sanctus Sanctus

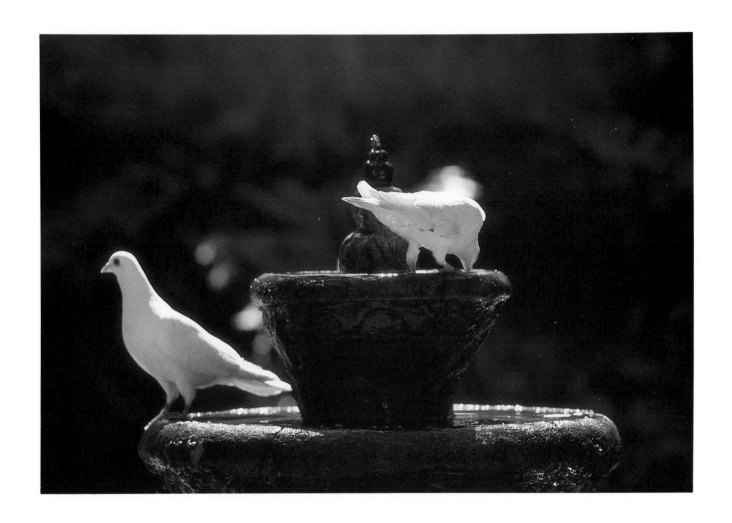

14 *(left)* Altar, San Juan Capistrano.

15 Doves, San Juan Capistrano.

16 & 17 Crystal Cathedral of Garden Grove Community Church (1980). Towering above a landscape that was nothing but citrus groves until after World War II, 10,660 panels of glass make the most of Southern California's perpetual sunlight. Back in 1955 the Rev. Dr Robert H. Schuller converted a 1400-car drive-in theatre into the first drive-in church, then later built a 15-storey Tower of Hope. The Crystal Cathedral is the third of his structures to meld the Orange County life-style with church attendance, as the 90-foot walls beside the pulpit swing open to allow drive-in worshippers to share with the 3000-strong congregation these remarkable services that are broadcast across America and beyond.

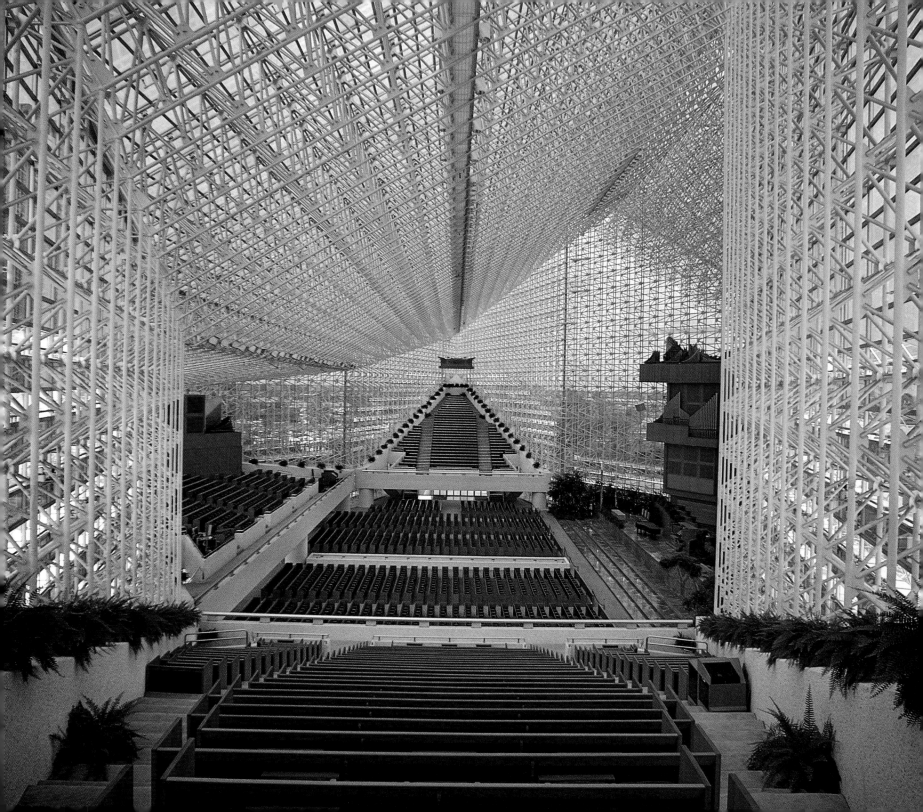

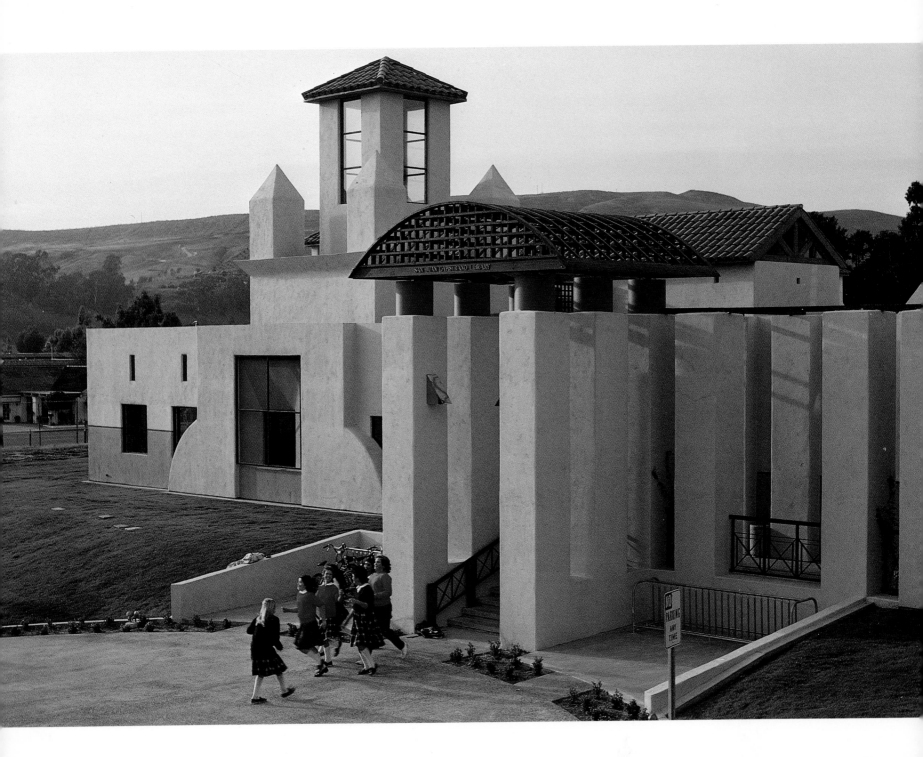

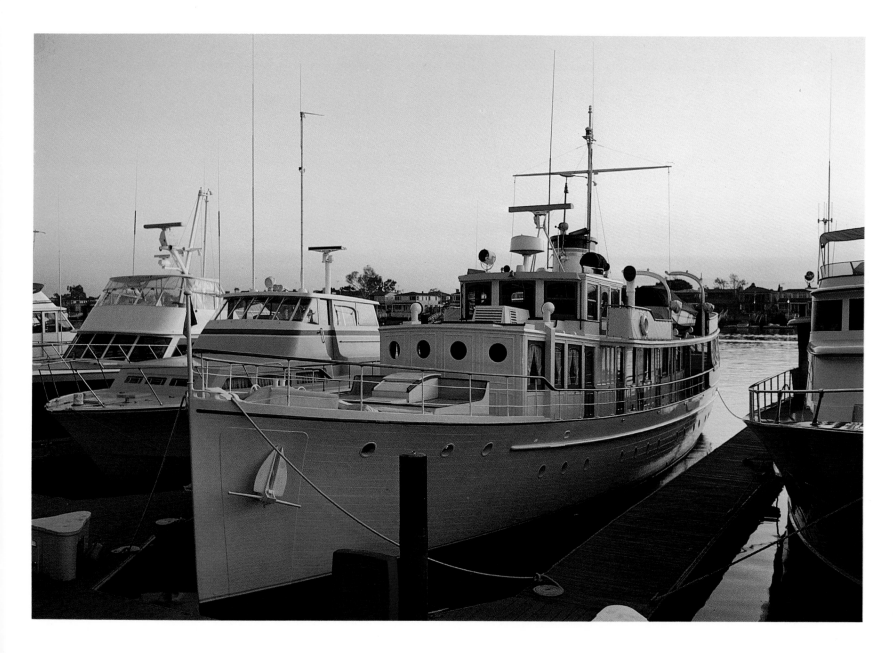

18 *(left)* San Juan Capistrano Public Library (1983); architect Michael Graves designed the building to incorporate traditional Spanish colonial features with Mayan and Mediterranean influences, and to be independent of but compatible with the architecture of the nearby mission.

19 Yachts, Balboa Yacht Club; another prime shopping and recreational area, Balboa is on a group of islands at the mouth of Newport Harbor.

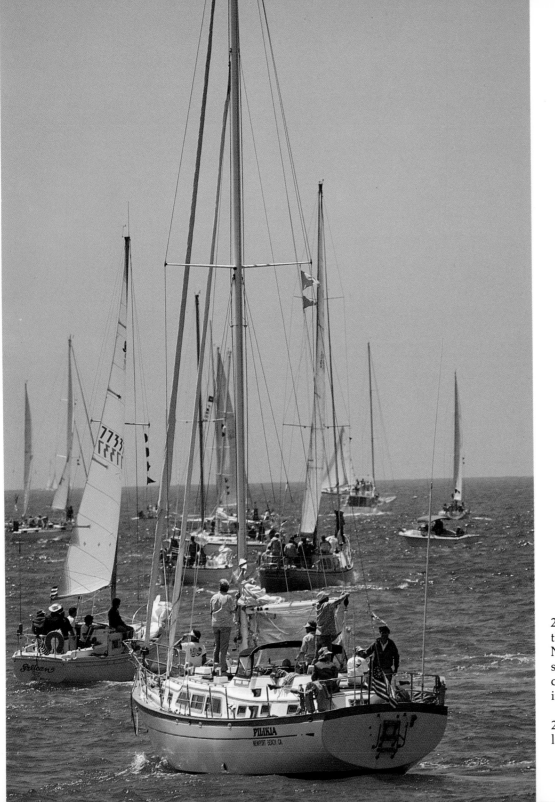

20 Sailing off Newport Beach; estimates of the number of yachts and pleasure-craft in Newport vary from eight to nine to ten thousand or more, including massive ocean-going craft fit for royalty and houseboats covered in bougainvillea and vines.

21 (right) Coming into the Lido Marina Village, Newport Beach.

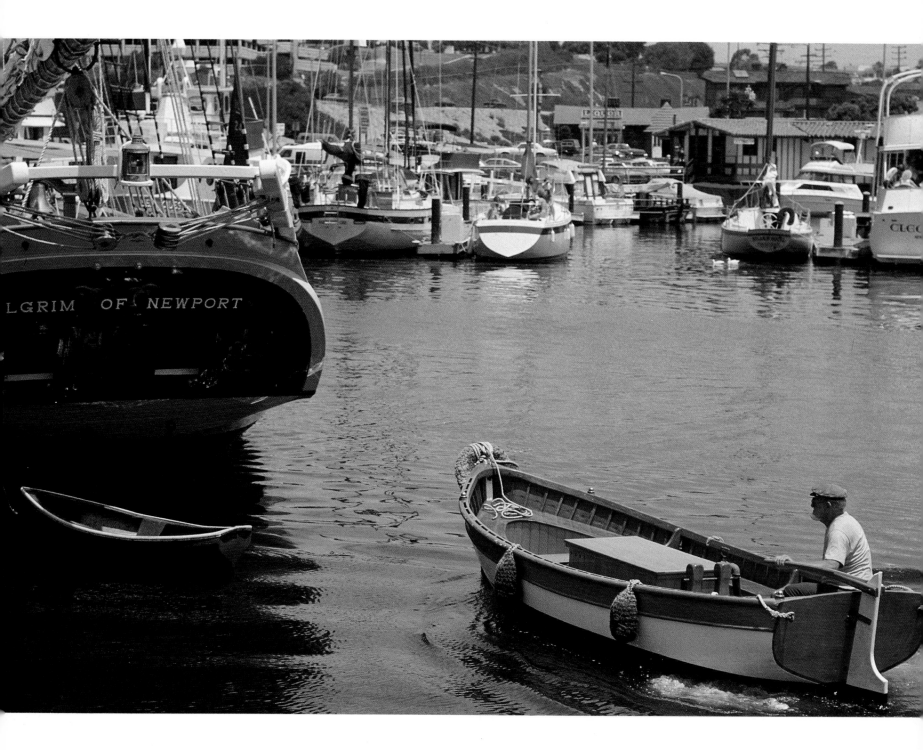

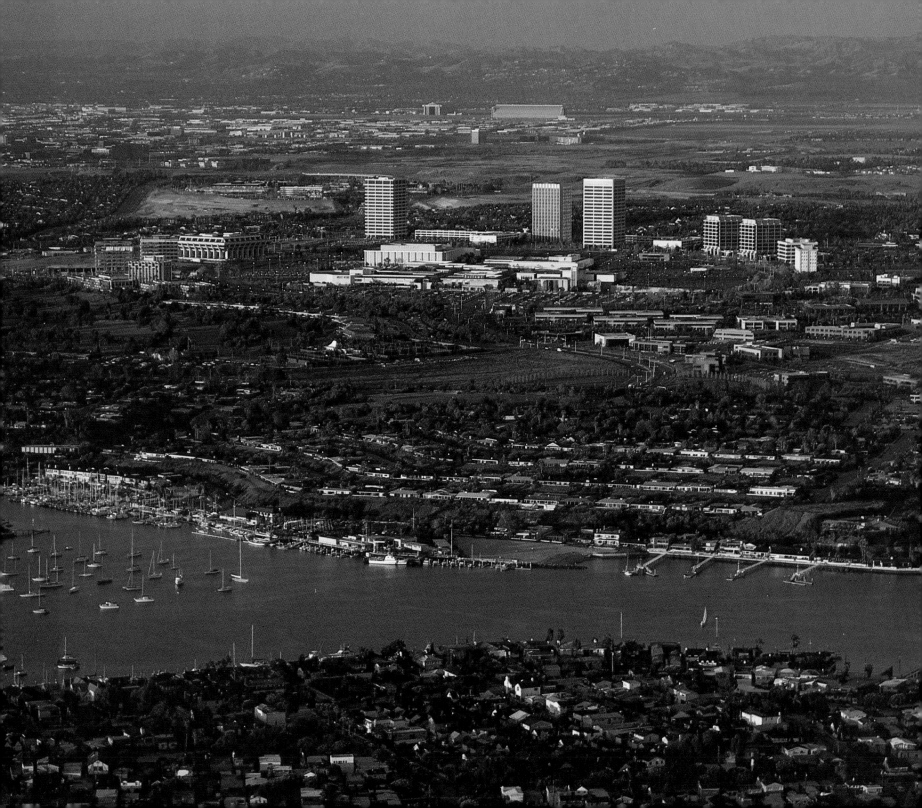

22 *(left)* Balboa Bay from the air, with Newport Center in the background. Newport Center, a showplace of high-rise offices and low-rise shopping, arrayed so that each building has a view, houses the headquarters of the Irvine Company, major landowner and developer in Orange County. The Irvine Ranch was formed in the 1860s by the consolidation of vast *ranchos* held by the early Californian Sepulveda and Yorba families. At one time comprising more than one hundred thousand acres, it stretched from the Santa Ana Mountains to the sea. The Ranch began development in the mid-1960s with the creation of the new University campus (see plate 39) and the city of Irvine was incorporated in 1971. Sold for over 300 million dollars to a private consortium in 1977 and then consolidated into single ownership at a value of one billion dollars in 1983, the Irvine Company continues its planned development process, creating a series of urban communities though still owning a sizeable portion of the County, with vast areas still in rangeland.

23 Aerial view of South Laguna (see overleaf).

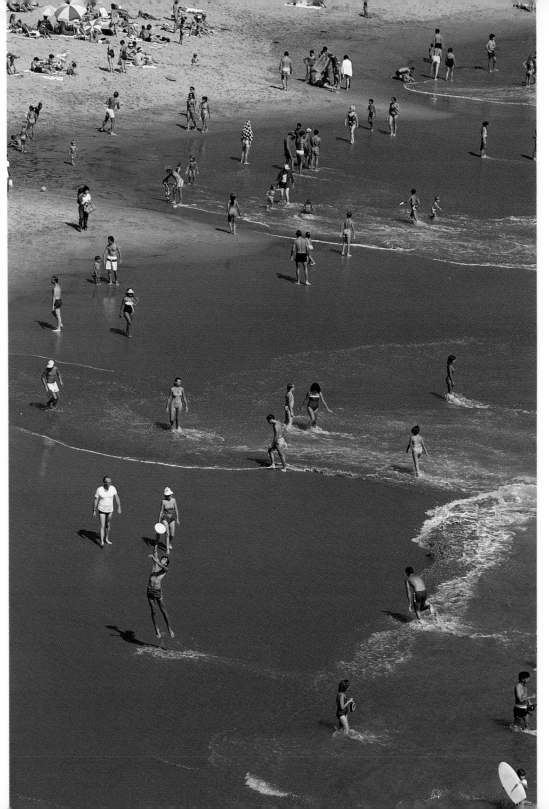

24 Summer-time, Laguna Beach. Further down the coast than Newport, and so more remote from Los Angeles, Laguna has kept some of the character of a small, seaside town. Its flower-covered cliffs and curving white sands have attracted artists since the early years of this century (see plate 70) and they in turn have brought in studios, galleries and craft shops for which Laguna is well known.

25 (right) Aliso Beach, South of Laguna Beach, excellent for swimming and surfing.

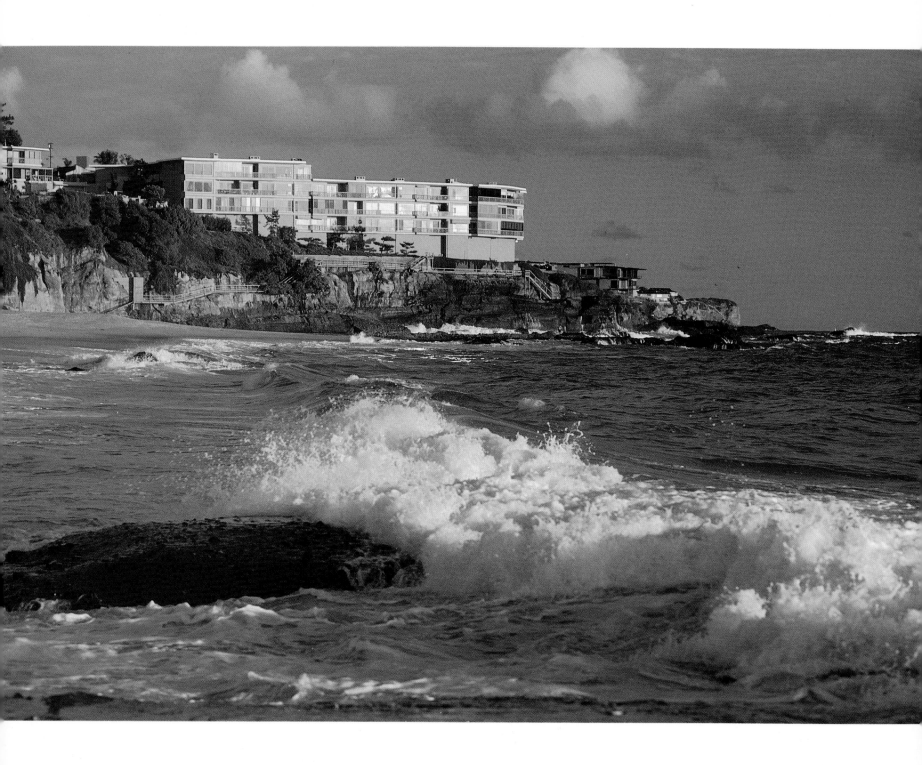

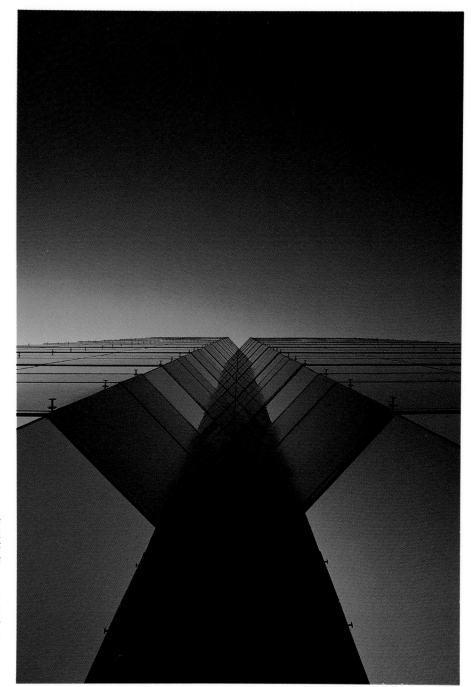

26 *(left)* Laser technology, Irvine. What were once thousands of acres of rangeland and orange groves now house the University of California, Irvine (plate 39) and the city of Irvine, with numerous shopping centres, apartment complexes, marinas, golf-courses, country clubs, churches, and an airport, not to mention aerospace industry, high technology, chemical and pharmaceutical companies—all this in less than 30 years.

27 Office-building detail, Newport Beach.

28 Architectural detail in Irvine, a city less than 25 years old and now one
of the largest in Orange County.

29 Bas-relief design, Newport Center (see also plate 22).

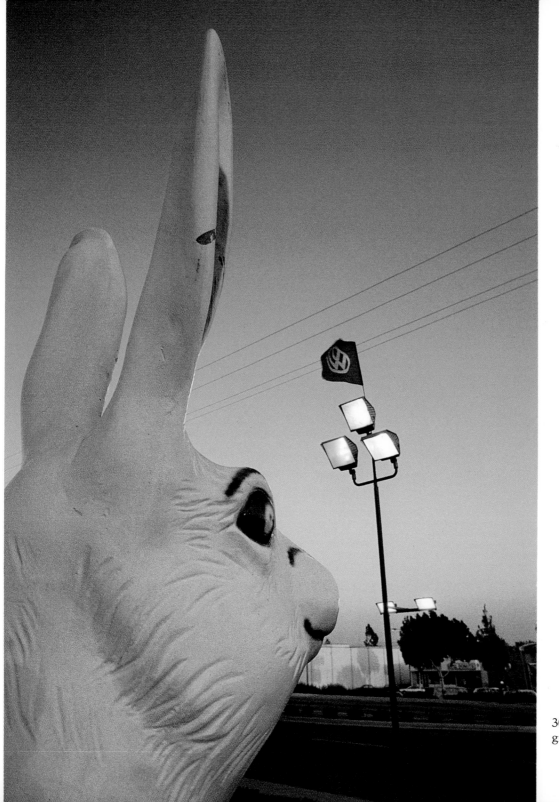

30 Rabbit with Volkswagen lot in the back-
ground, Placentia.

31 Sculptural detail, South Coast Plaza, Costa Mesa. Developed by Henry Segerstrom on family land that had once raised lima beans, South Coast Plaza is one of the most profitable shopping centers in the world.

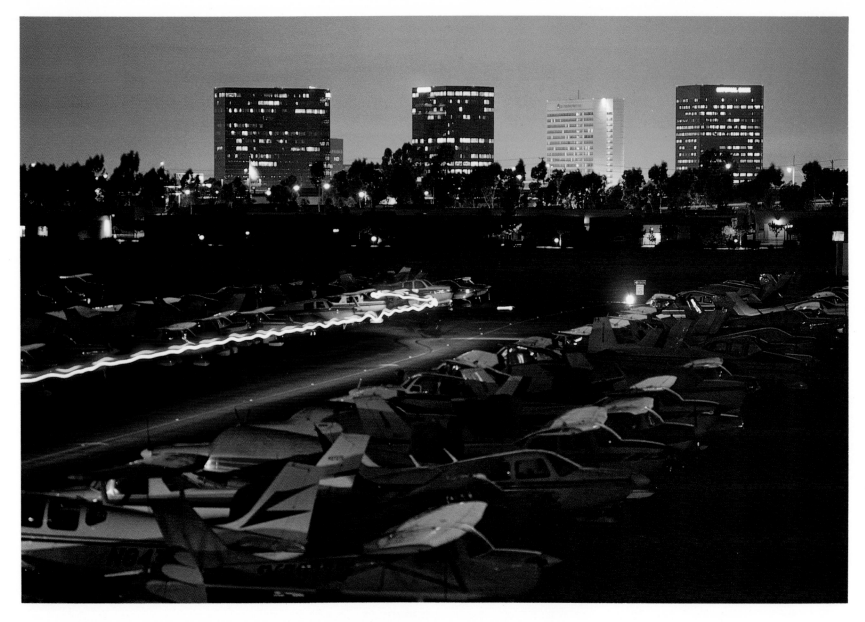

32 Dusk at John Wayne–Orange County Airport, Costa Mesa, looking towards South Coast Plaza; John Wayne is one of the busiest airports in the entire nation.

33 *(right)* Laguna Beach, looking towards the Santa Ana mountains.

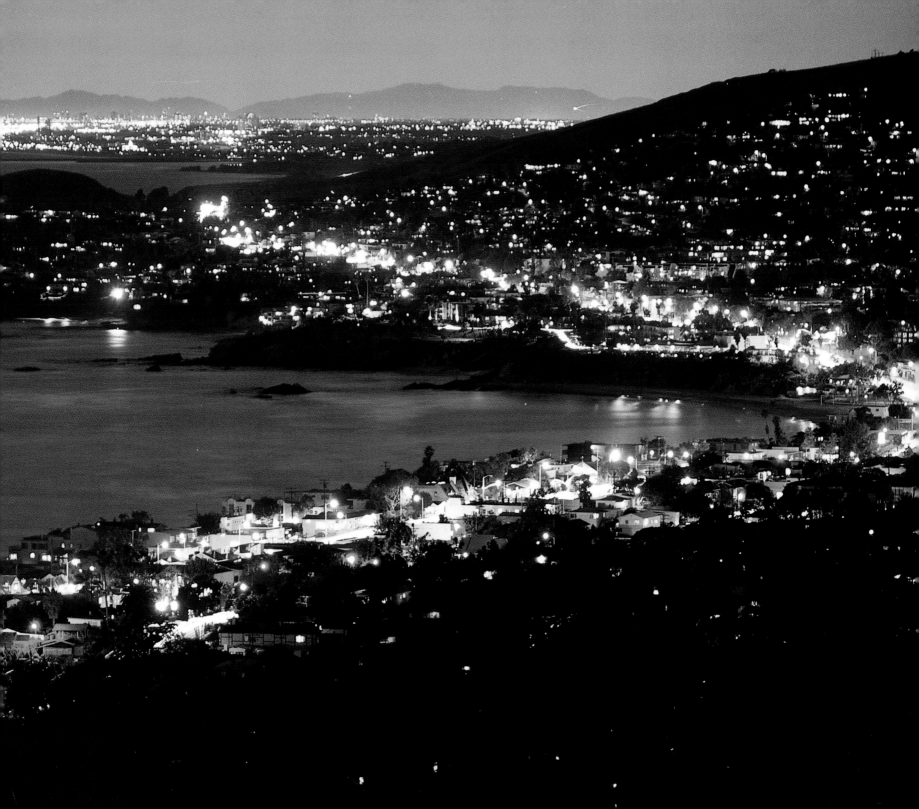

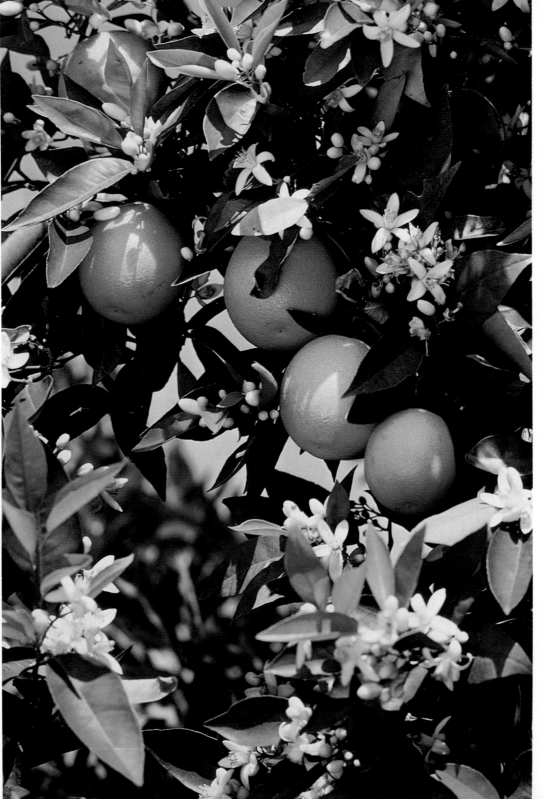

34 Orange County derives its name from the groves that helped to make California the major producer of oranges in the nation. Now the sight shown here is becoming increasingly rare as urban development takes over the agricultural land.

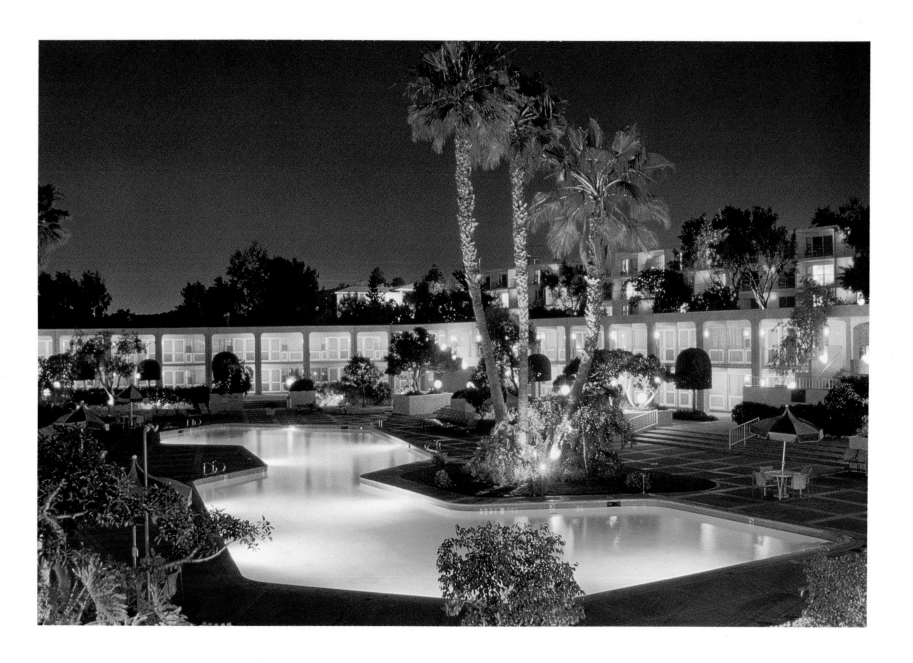

35 Del Webb's Newporter Inn, Newport Beach, a long-established luxury resort complex overlooking upper Newport Bay and across the street from the Irvine Country Club.

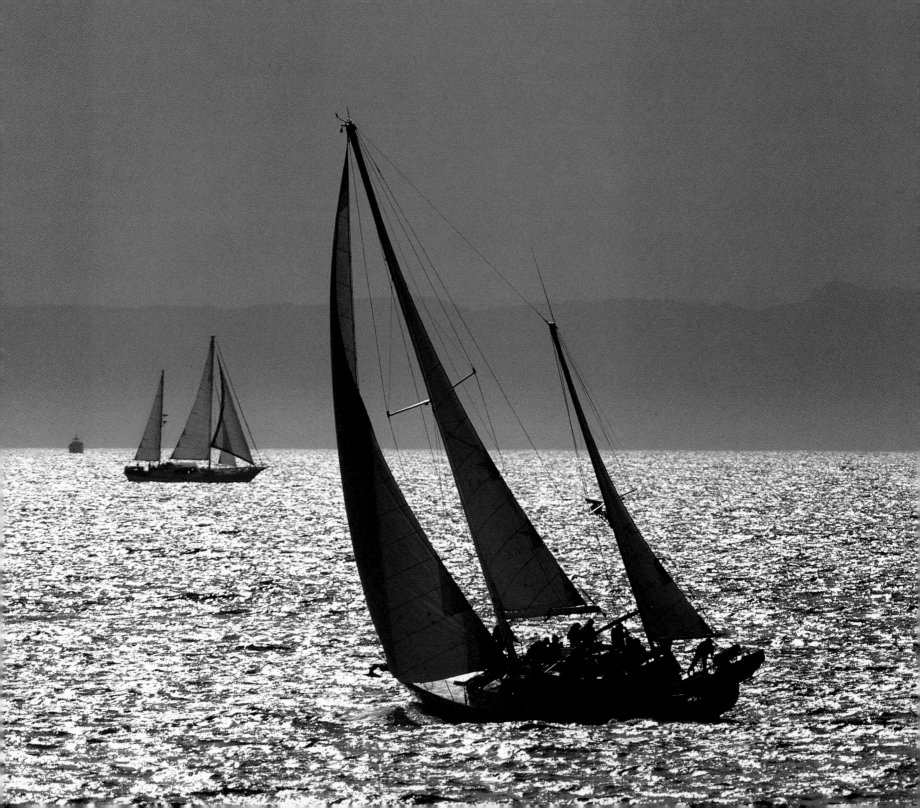

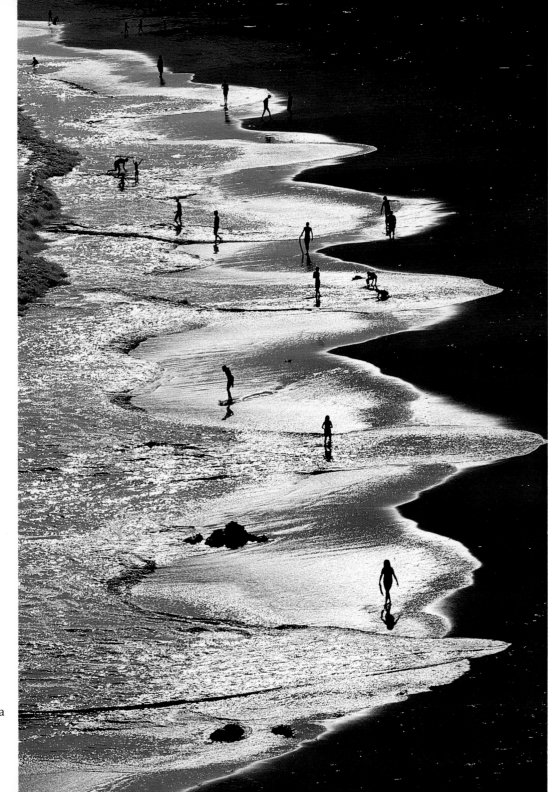

36 *(left)* Sailing, Newport Beach.

37 Patterns of light on the beach at Corona del Mar (see plate 80).

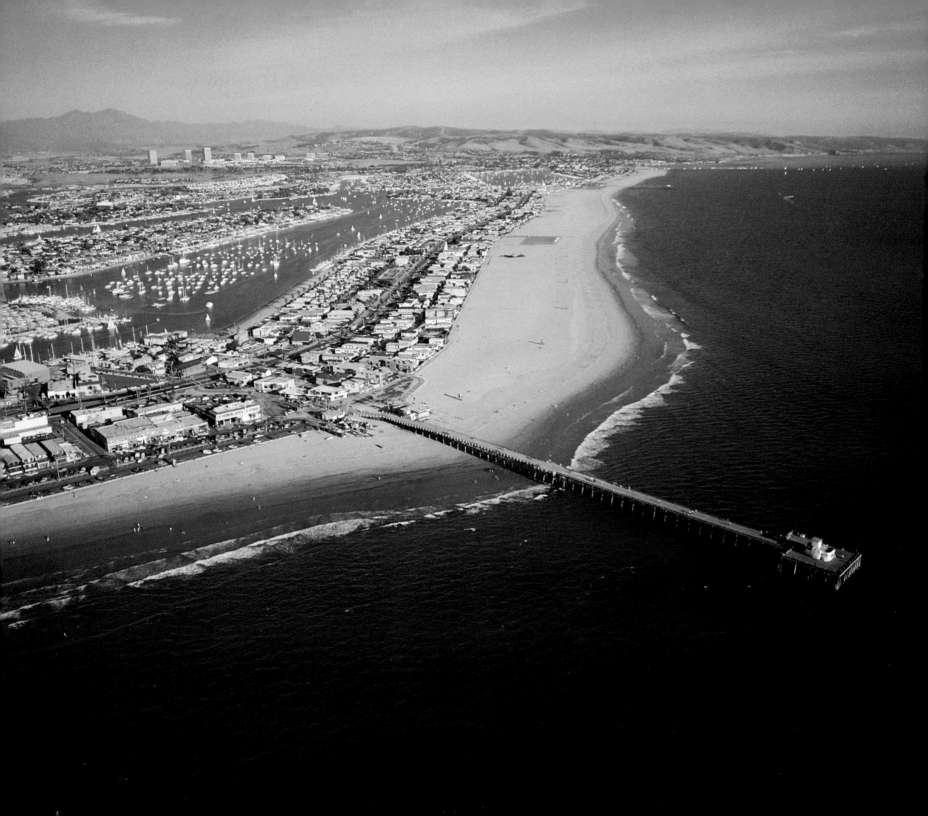

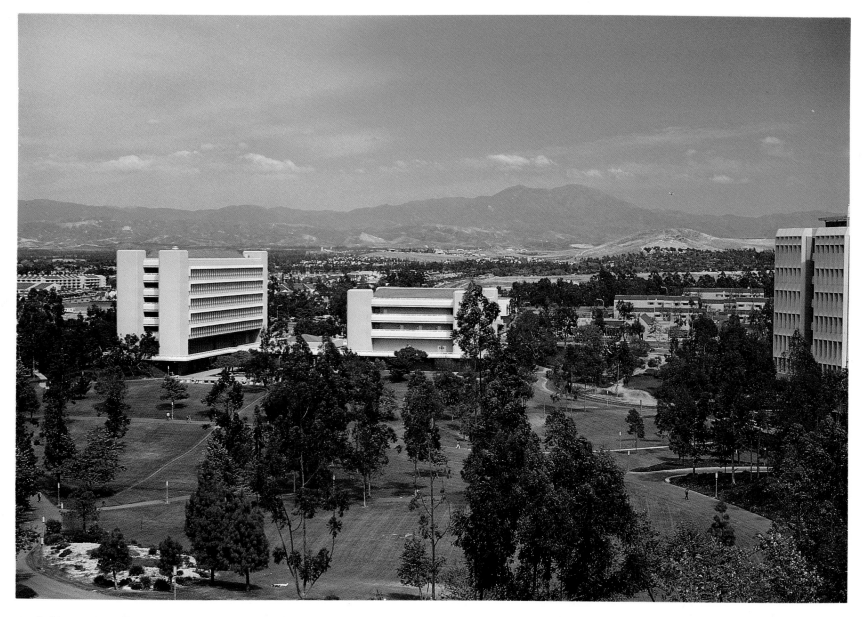

38 *(left)* Aerial view of Newport Pier with Balboa Bay in the background.

39 University of California, Irvine, founded 1965, a 1500-acre campus designed as a principal feature of the Irvine master-plan for development of the ranchland into a fully equipped community.

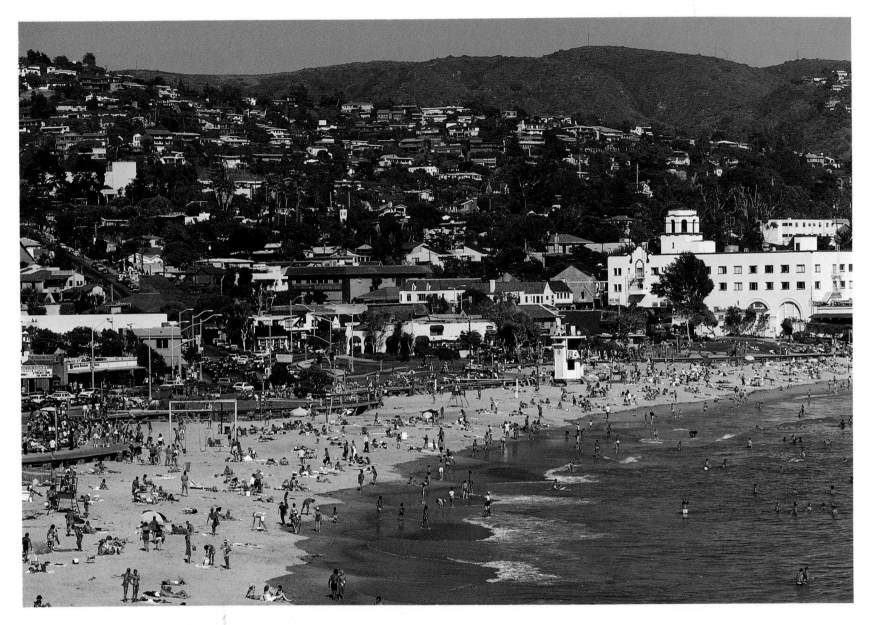

40 Summertime, Laguna Beach.

41 *(right)* Schooner in front of the Cannery Restaurant, in Lido Marina Village, a complex of many restaurants and shops off Newport Boulevard.

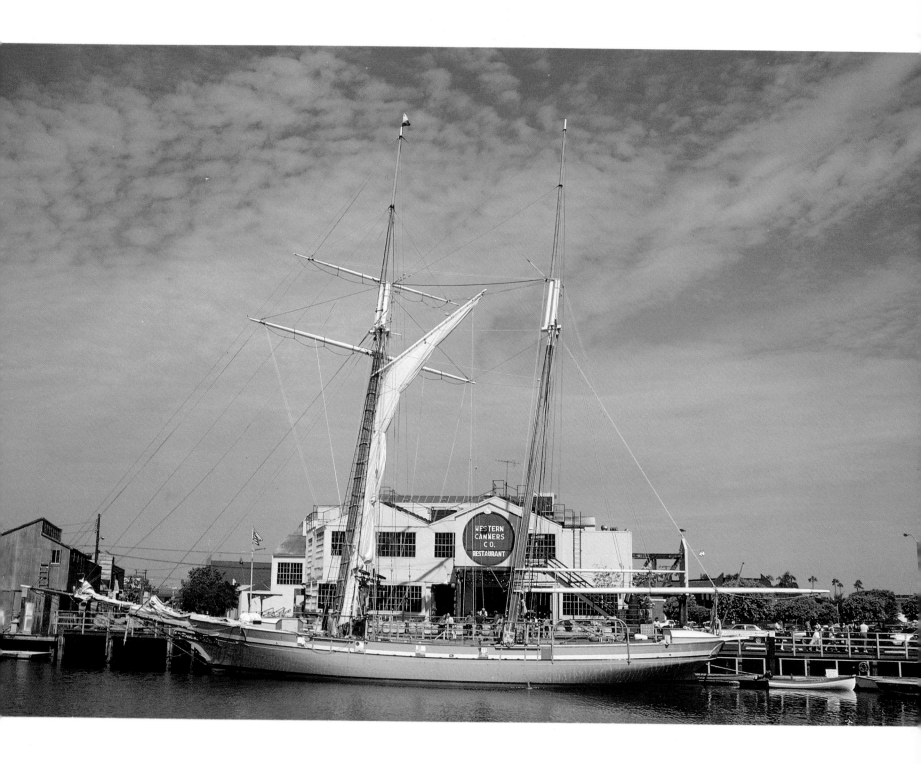

42 *(left)* Irvine Cove, just north of Laguna Beach.

43 Sherman Foundation Gardens, Corona del Mar.

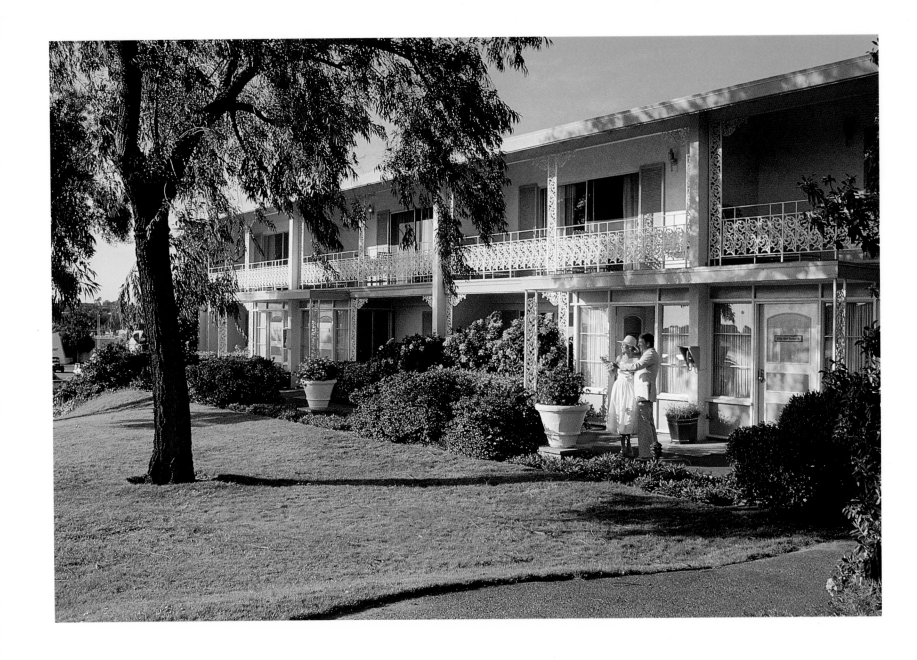

44 Private home on one of the many islands around Balboa Bay.

45 Orange County is rich in beautiful parks
and public gardens.

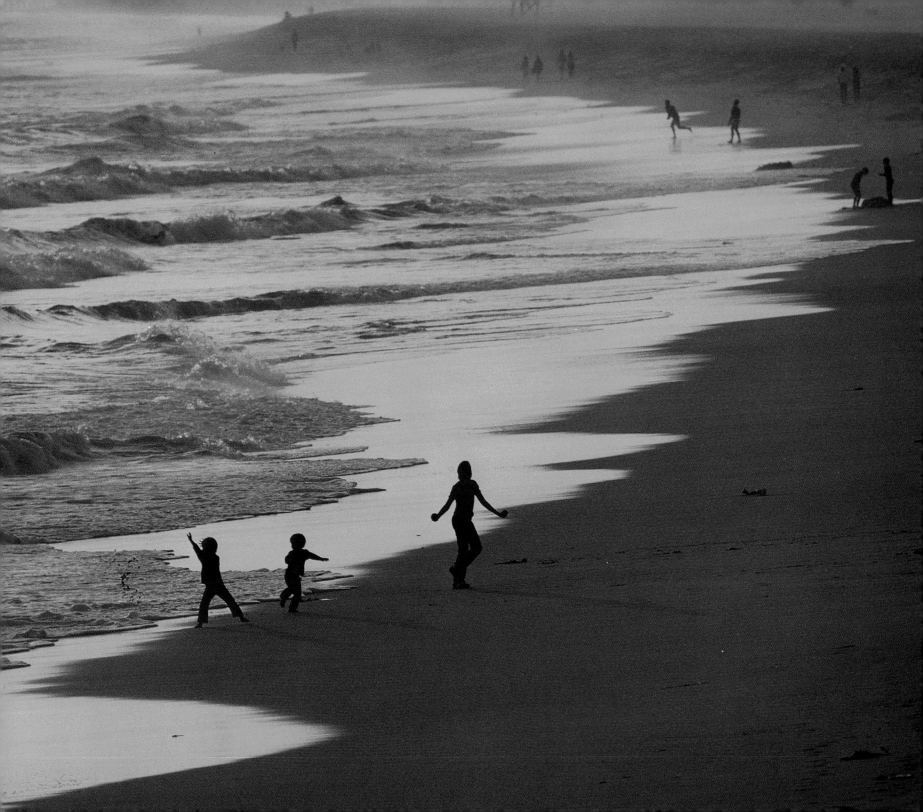

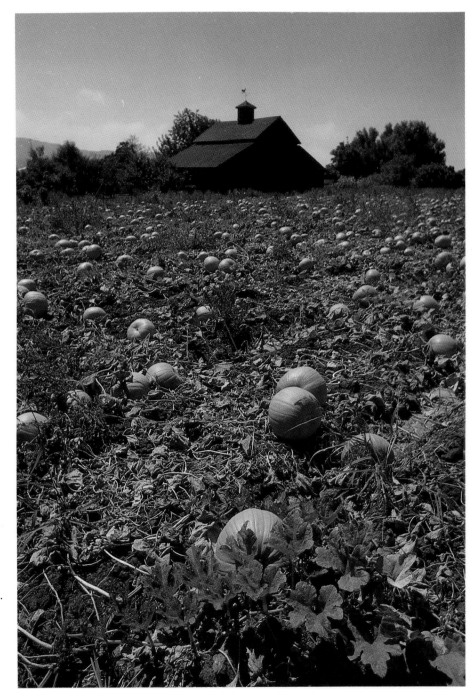

46 (left) Sunset on Newport Beach.

47 Pumpkin-field near San Juan Capistrano.

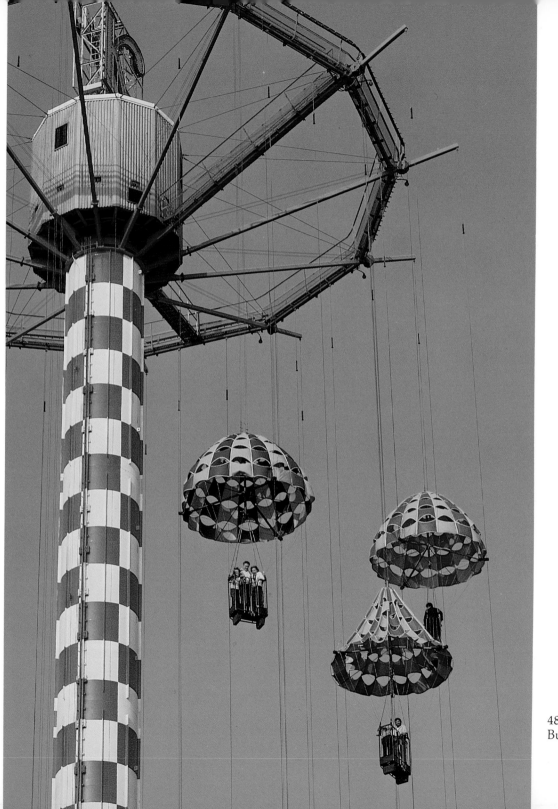

48 Parachute Tower, Knott's Berry Farm, Buena Park (see plates 2-5).

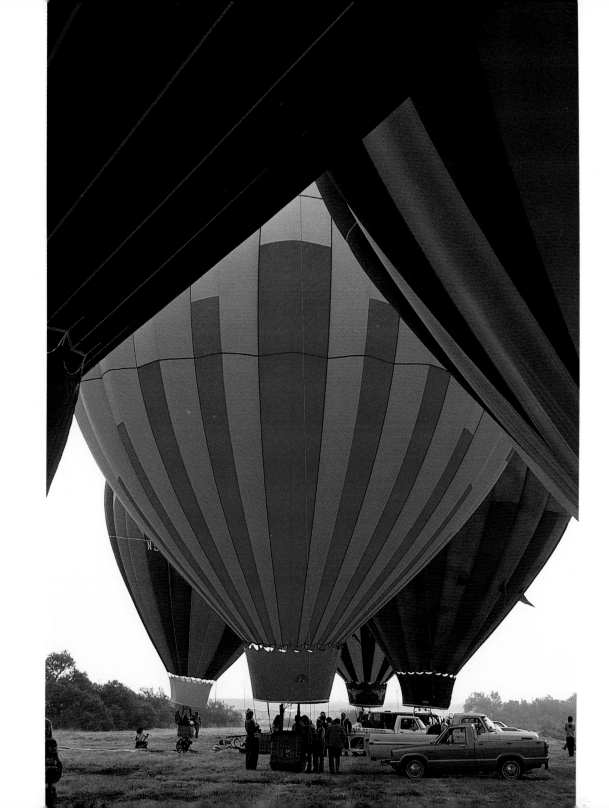

49 Balloon meet, Fountain Valley.

50 Balboa Beach sign, Newport Beach.

51 Le Bistro sign, Lido, Marina Village, Newport Beach.

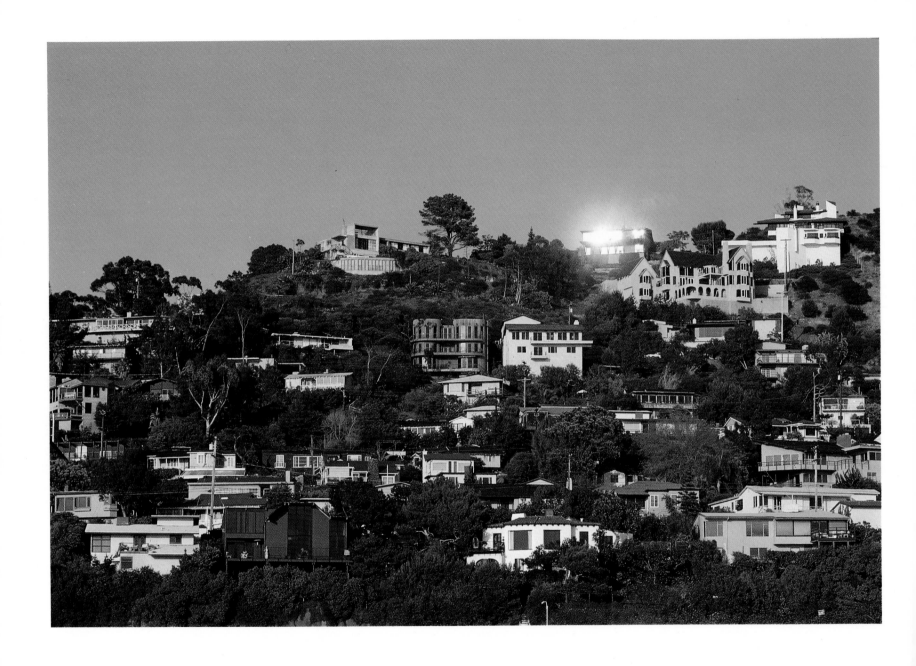

52 Hillside homes, Laguna Beach.

53 *(right)* Aerial view of South Laguna.

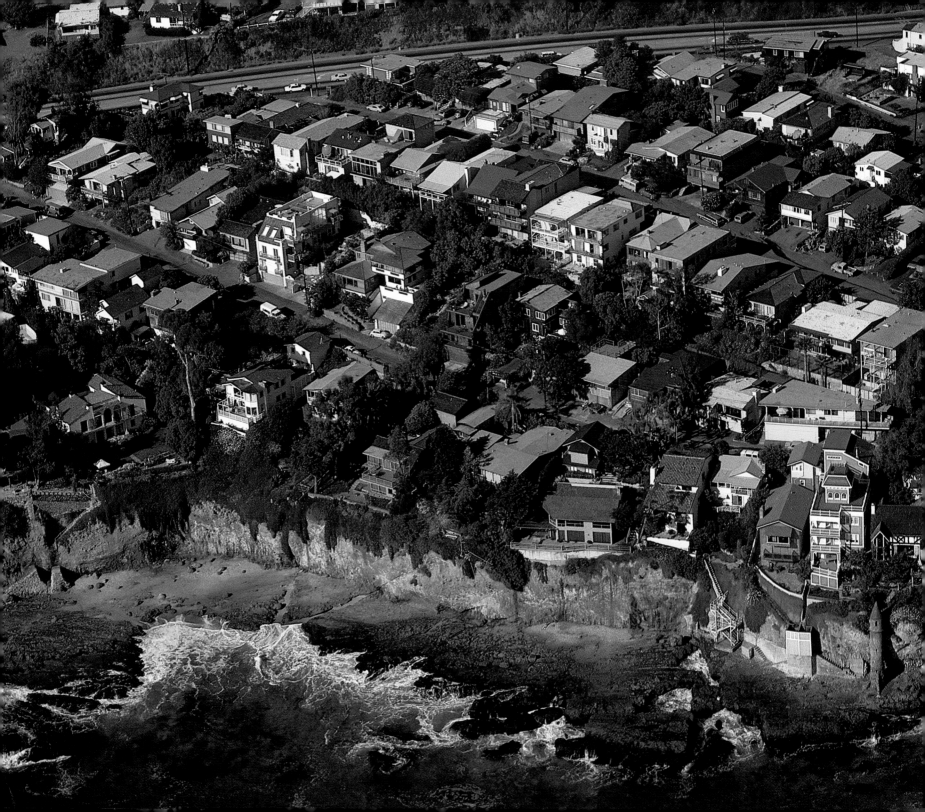

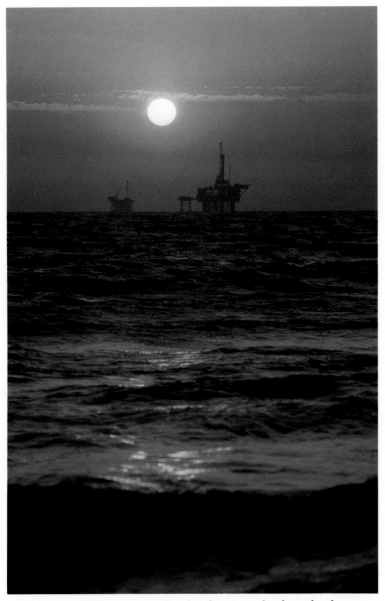

54 Sunset off Huntington Beach; there are backyard oil-pumps along the shore, oil-wells beside the highway and full-scale oil-derricks far out to sea.

55 *(right)* Looking south-east from the San Diego Freeway towards the South Coast Plaza.

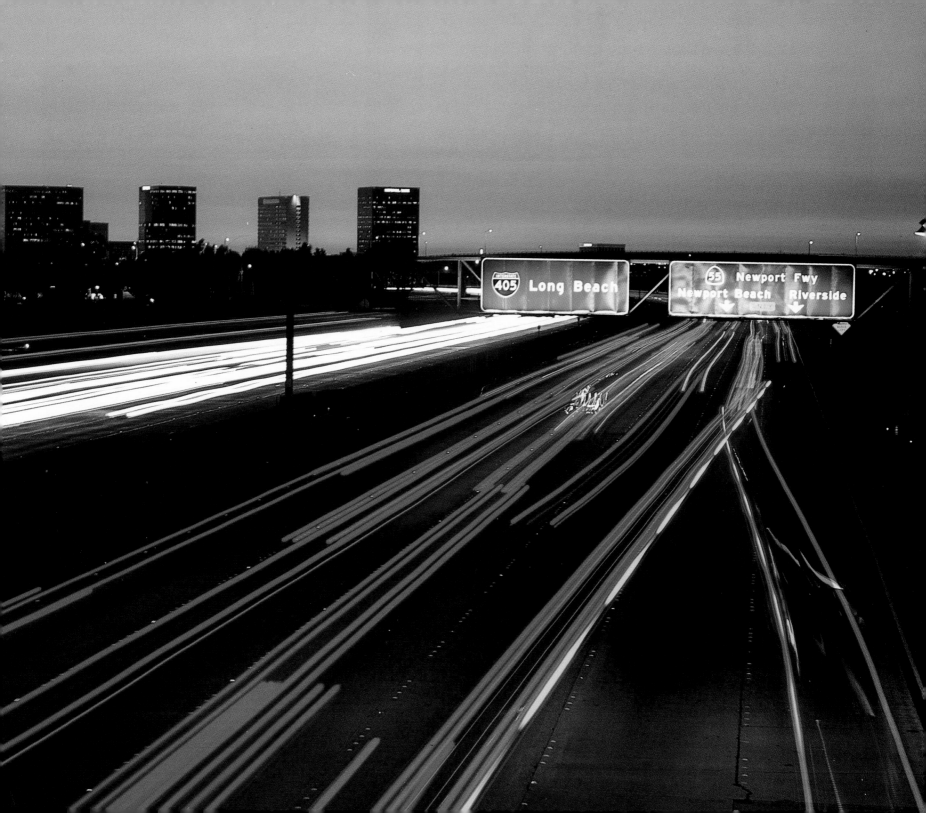

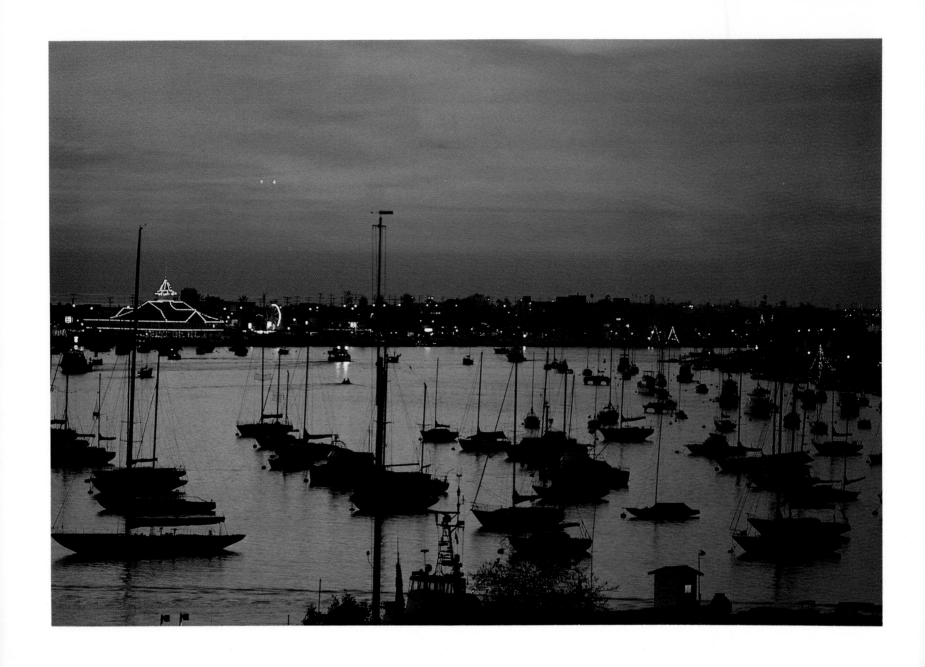

56 Sunset reflected off Balboa Bay with the Balboa Pavilion (see plate 83).

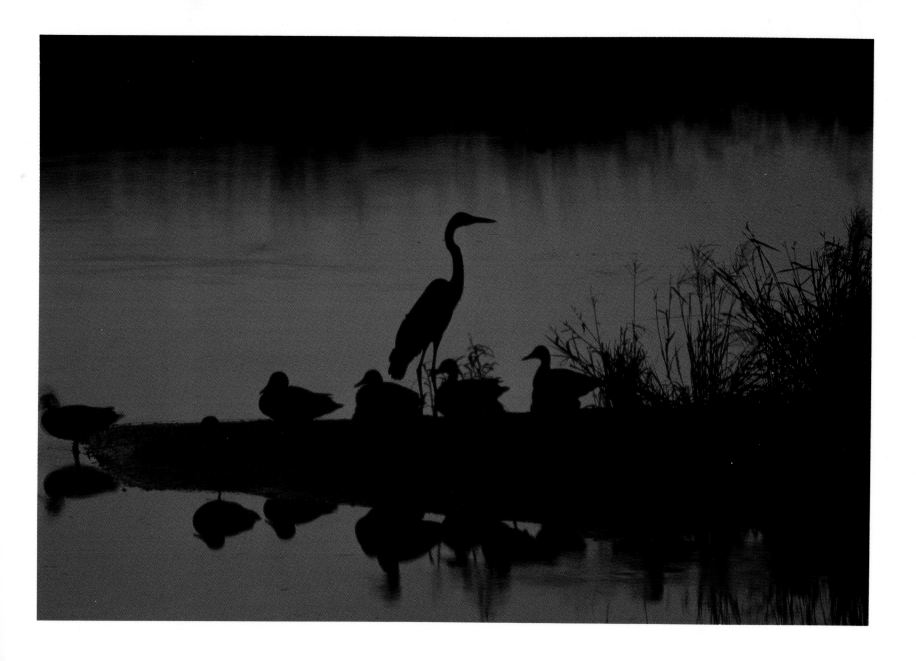

57 Heron and ducks, Newport Beach bay, a protected salt-water estuary
that is a major stop for many birds on their seasonal migrations between
Canada and South America.

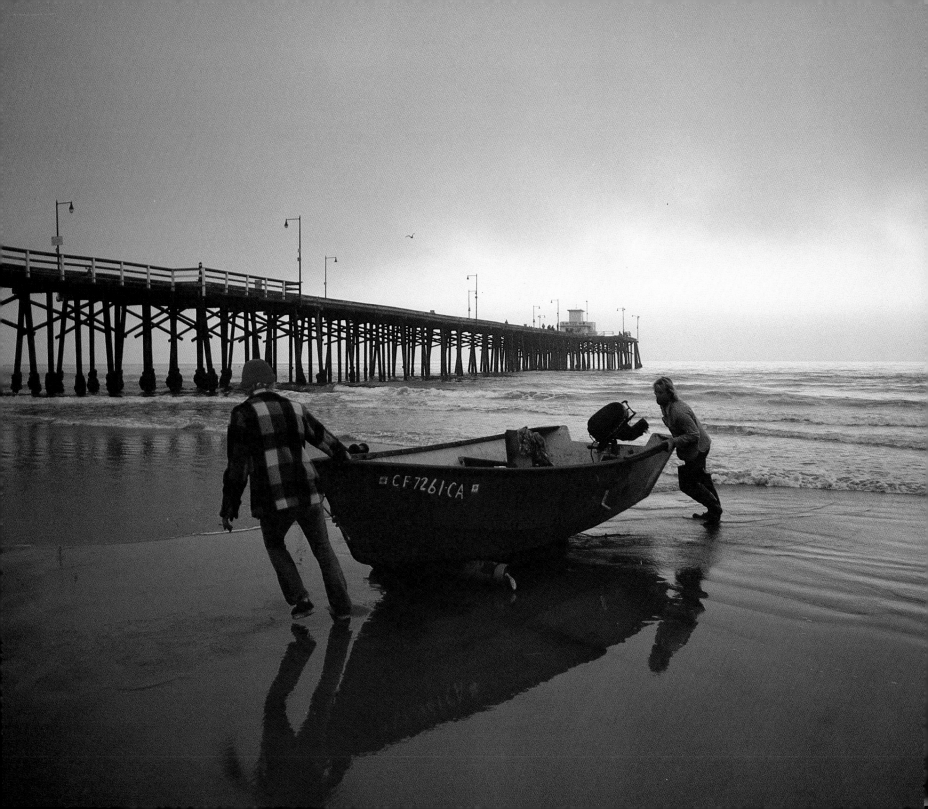

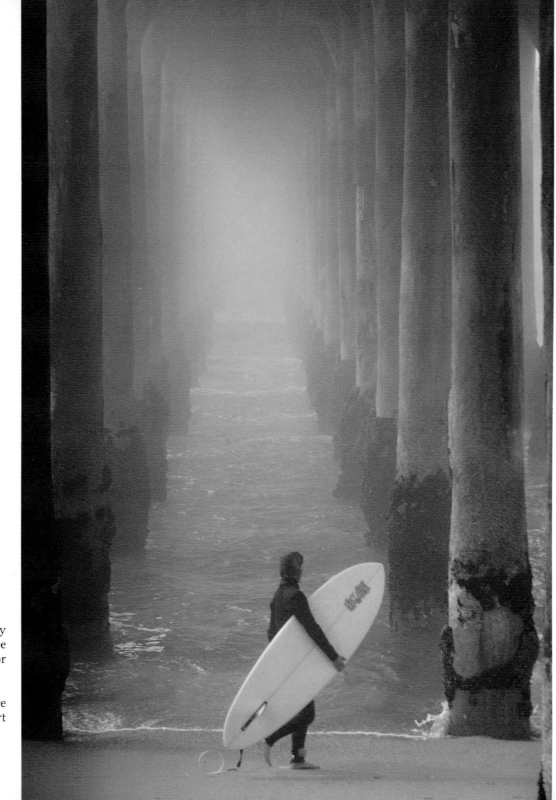

58 *(left)* Fishermen hauling up the early morning catch on Newport Beach, maybe flounder, or halibut, maybe rock-cod or mackerel.

59 Surfer at Huntington Beach Pier; here wave action around the pier draws expert surfers to a location famous for the sport.

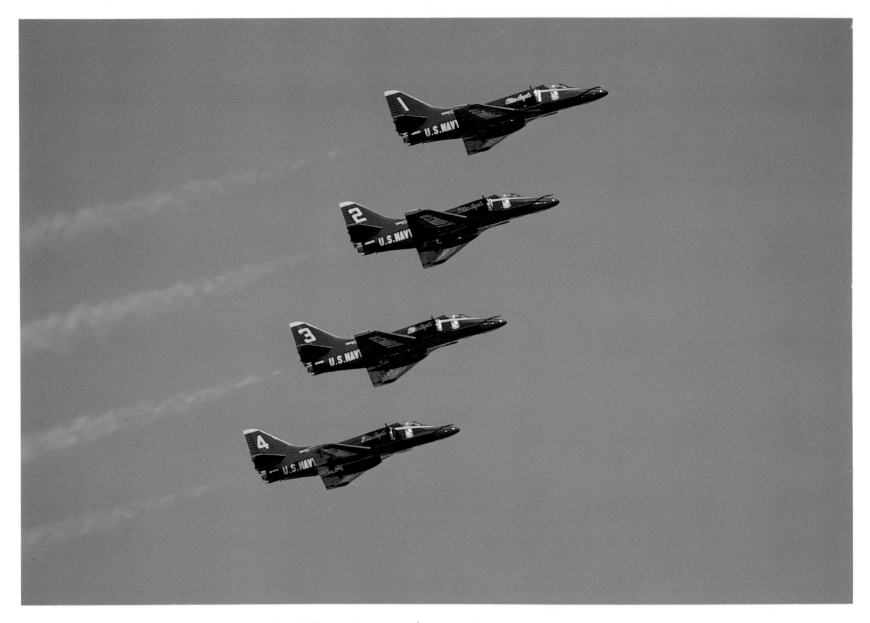

60 The 'Blue Angels' above Marine Corps Air Base El Toro, where most of
the Marines' air units on the West Coast are stationed.

61 *(right)* Surfer off Huntington Beach; Surfboard Championships are
held here very year.

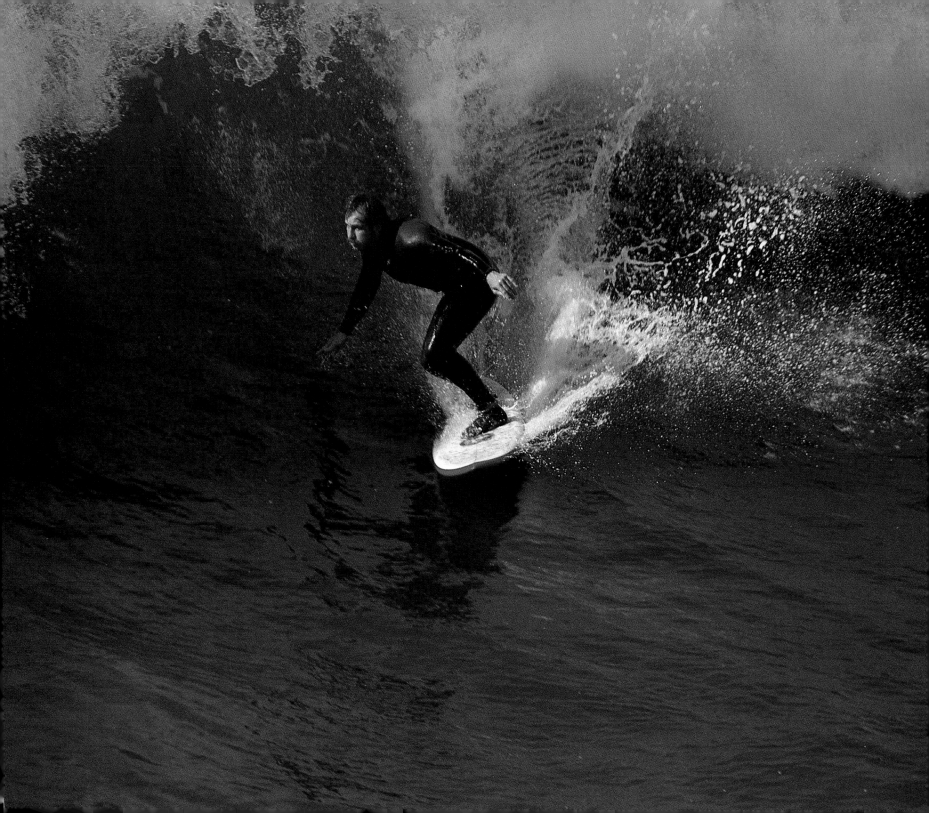

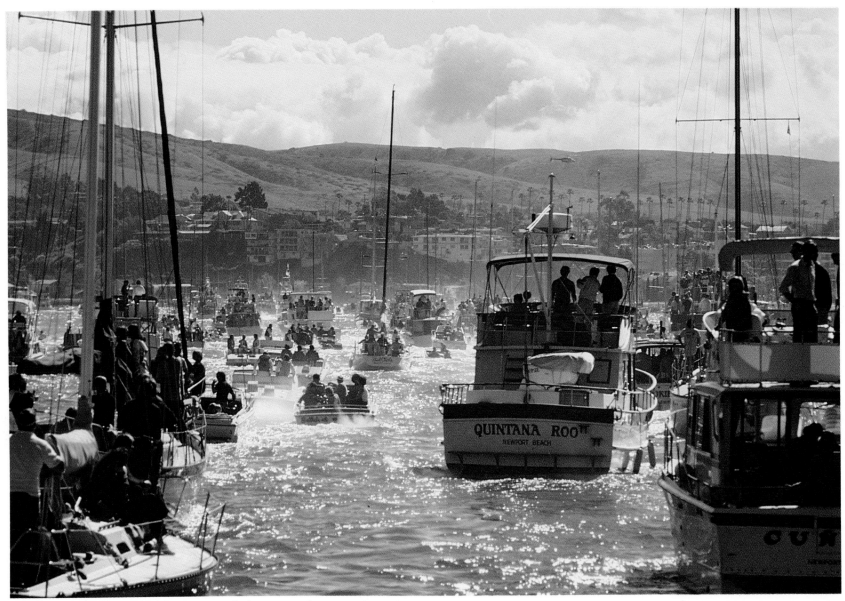

62 Boating on Balboa Bay, Newport Beach; here more than anywhere else
on the coast is boating the way of life.

63 *(right)* Regattas and racing go on year-round at Newport but here is
the start of the annual 125-mile race to Ensenada in Mexico, with some of
the 700 sailboats moving into position.

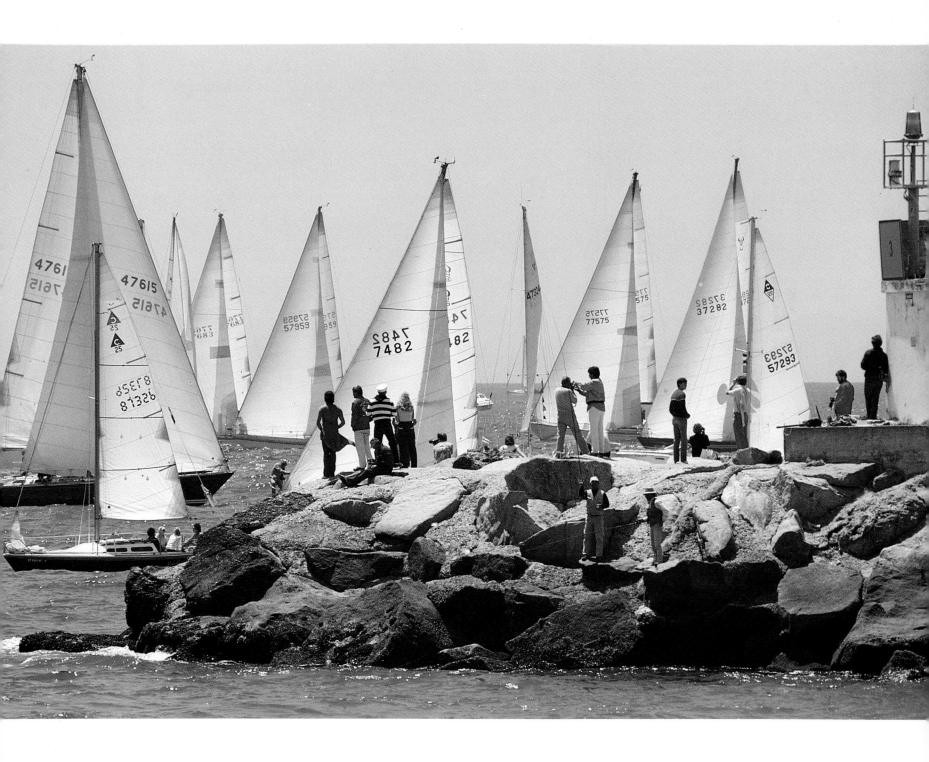

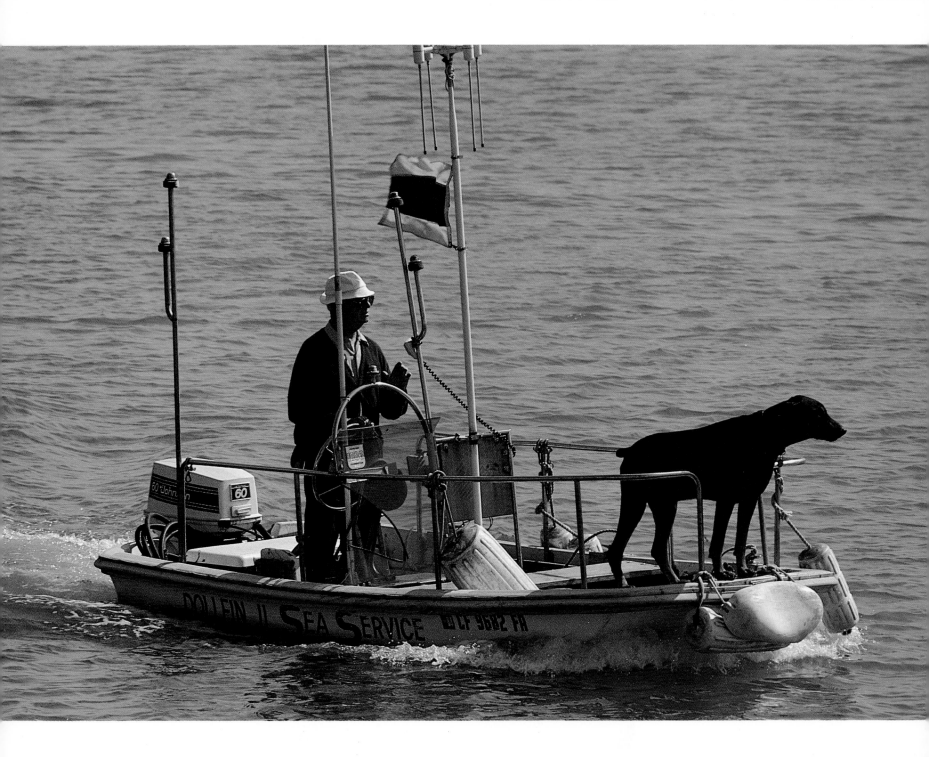

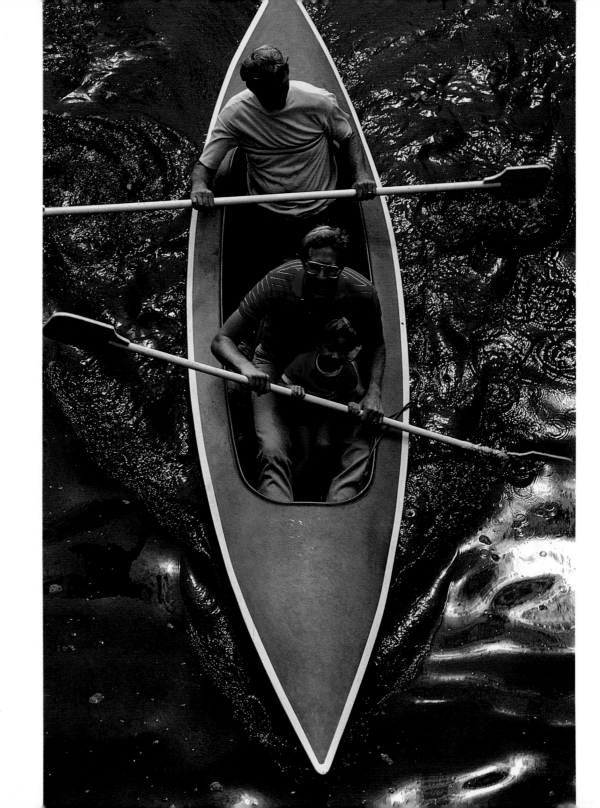

64 *(left)* Man and dog, Newport Beach.

65 Canoeing in the Lido.

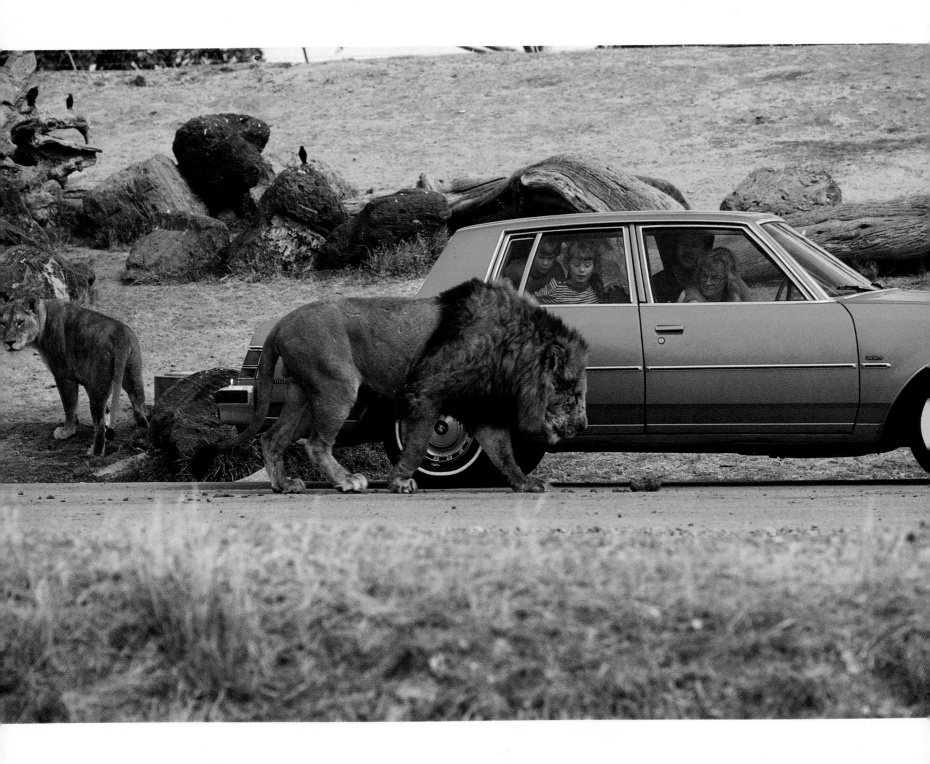

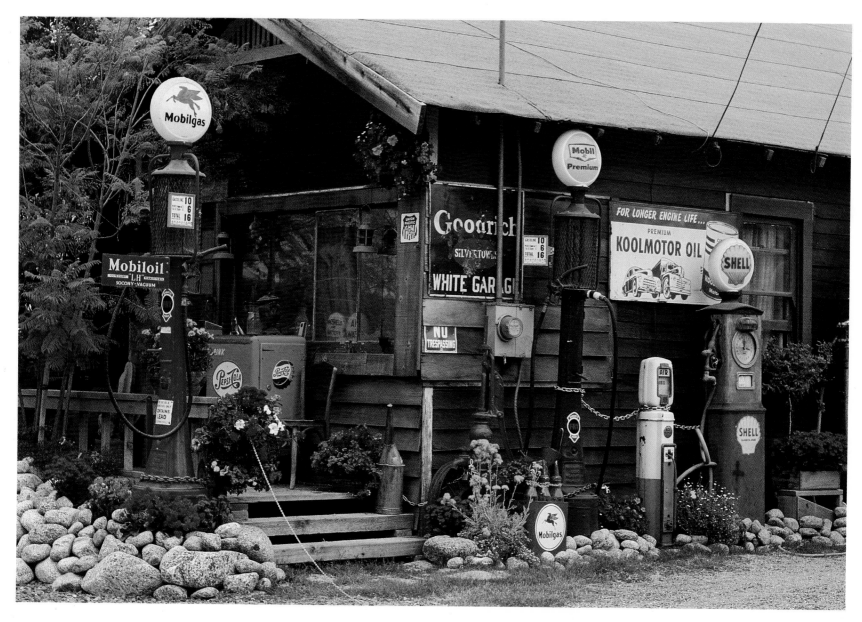

66 Lion Country Safari, a 500 acre reserve and breeding farm at Irvine, where lions, elephants, zebras, giraffes and other African animals roamed on the Laguna Hills, has long been a tourist focus of the region. As this book goes to press the area is being diversified to multiple recreational uses.

67 Old gas-pumps, San Juan Capistrano.

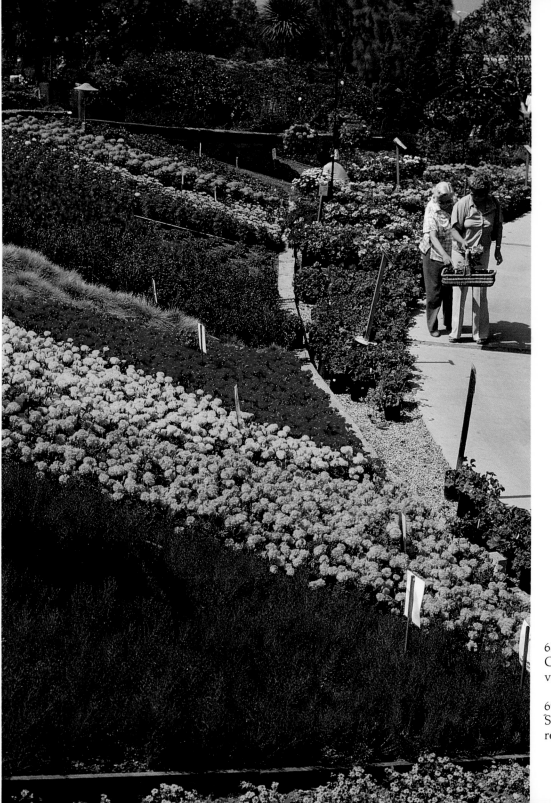

68 Roger's Gardens, across from Newport Center, a retail nursery so rich in color and variety as to be a regional attraction.

69 *(right)* Charles W. Bowers Museum, Santa Ana, houses Indian artifacts, pioneer relics and displays of regional history.

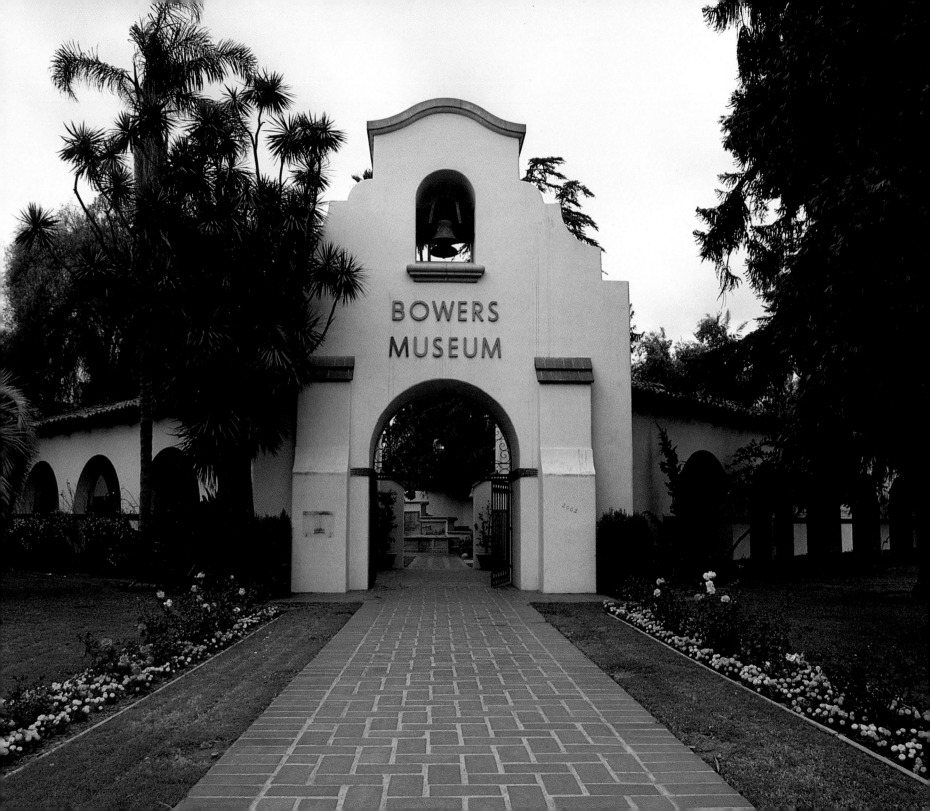

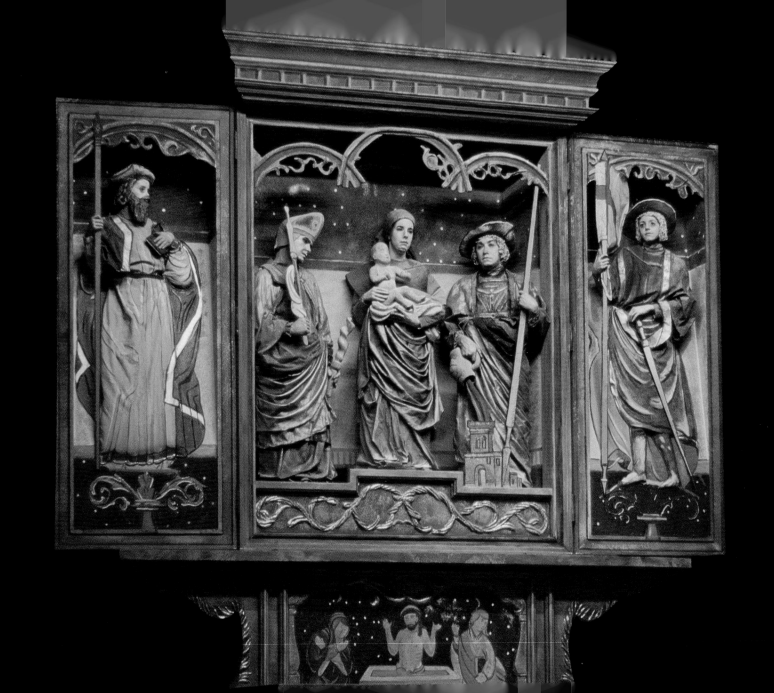

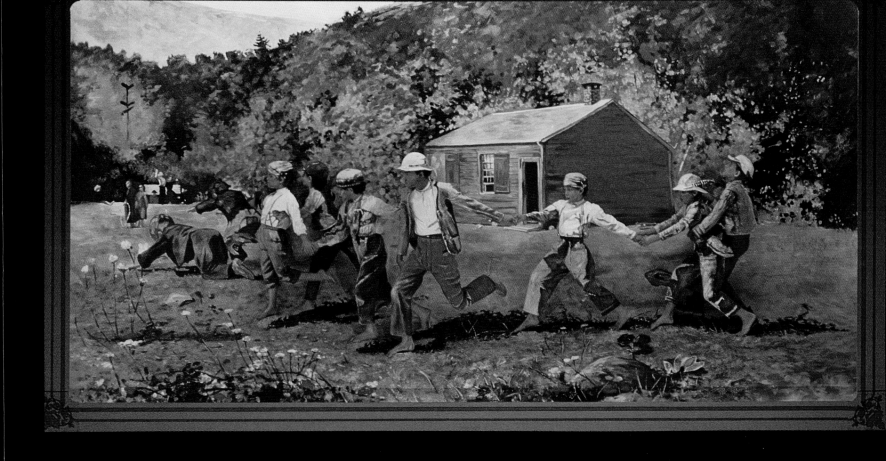

70-71 Pageant of the Masters, Laguna Beach. Annually from mid-July to mid-August, the residents stage in the Irvine Bowl a Festival of Arts and Pageant of the Masters in which the most celebrated feature is the recreation of famous works in live tableaux by people posing the different characters of the masterpiece portrayed. Strange as it may seem this on the left is not a medieval altarpiece, and this on the right is not a canvas by Winslow Homer, nor are they painted copies even—they are living people.

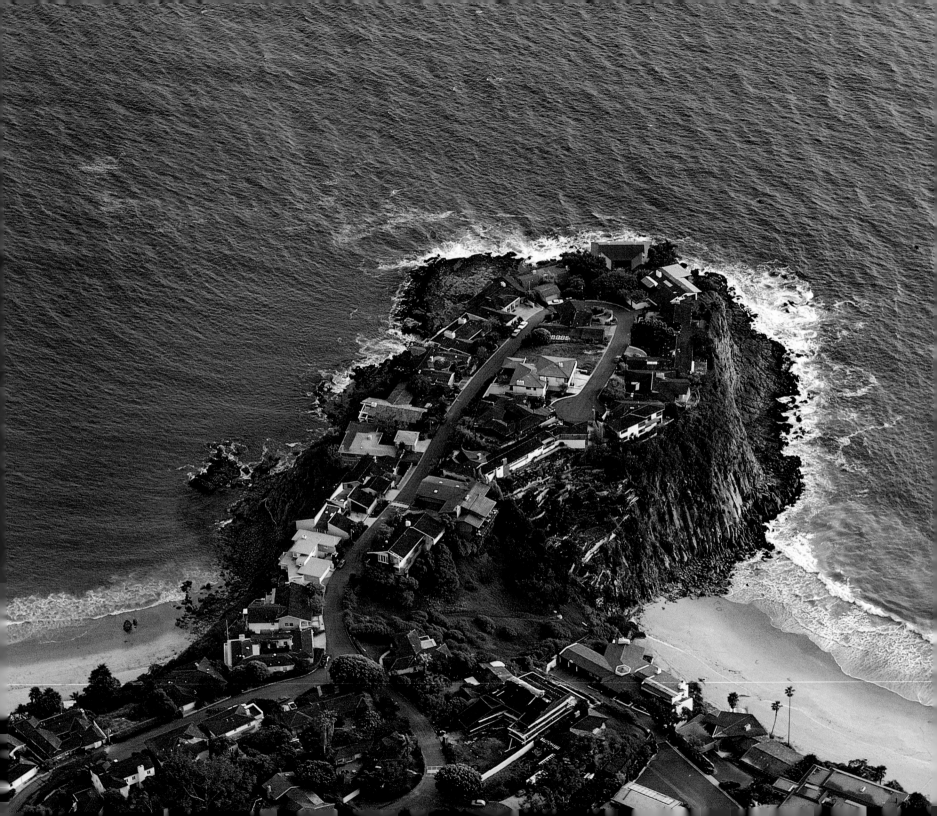

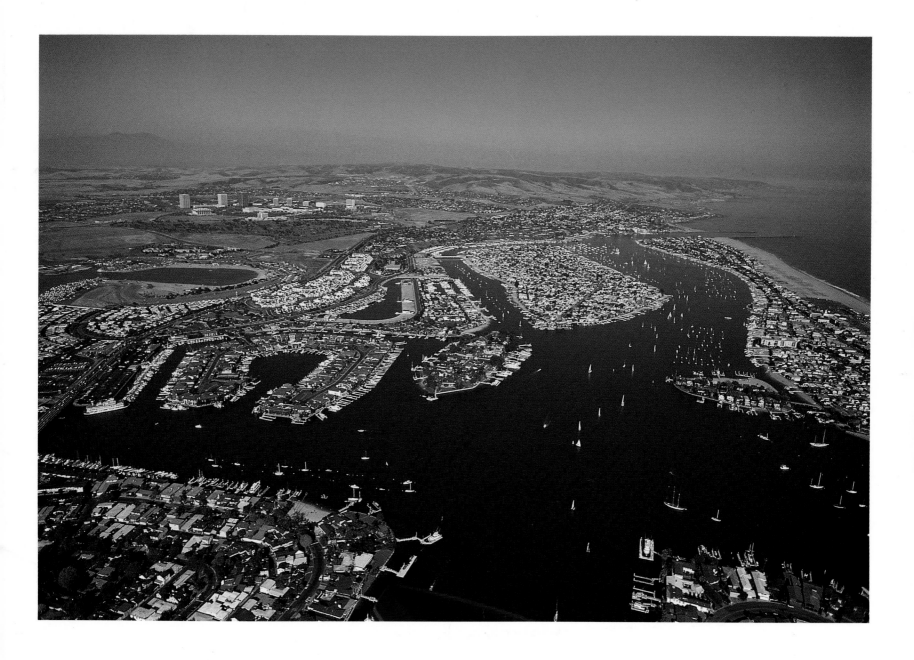

72 *(left)* Laguna Beach aerial (see also plate 24).

73 Looking down on Balboa Bay and Newport Beach (see also plate 22).

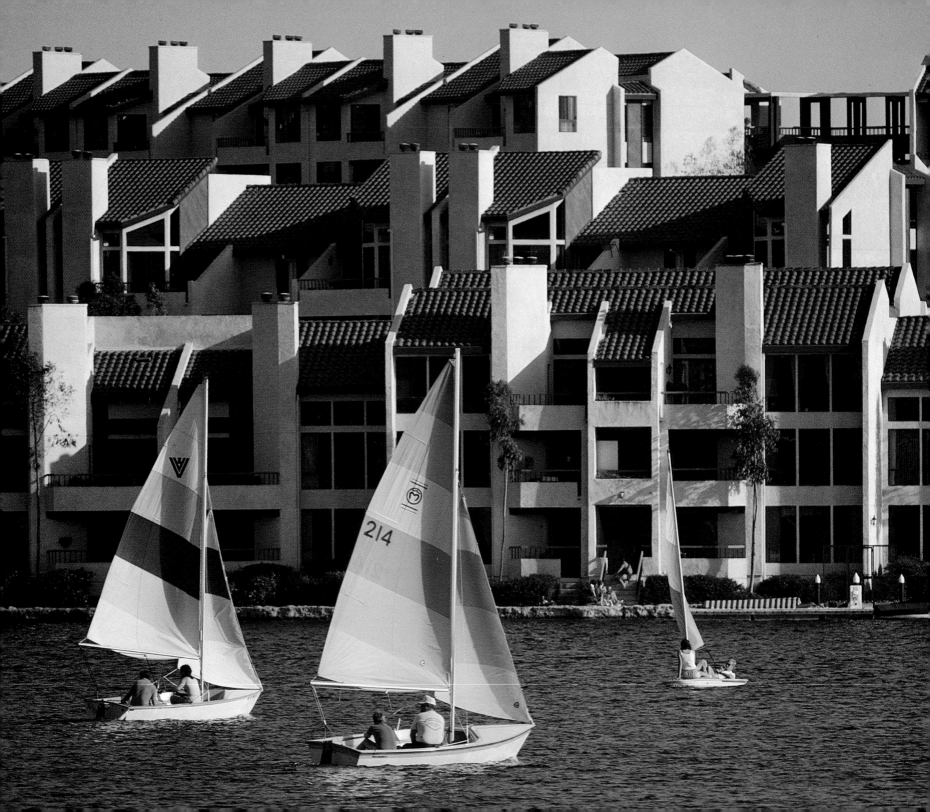

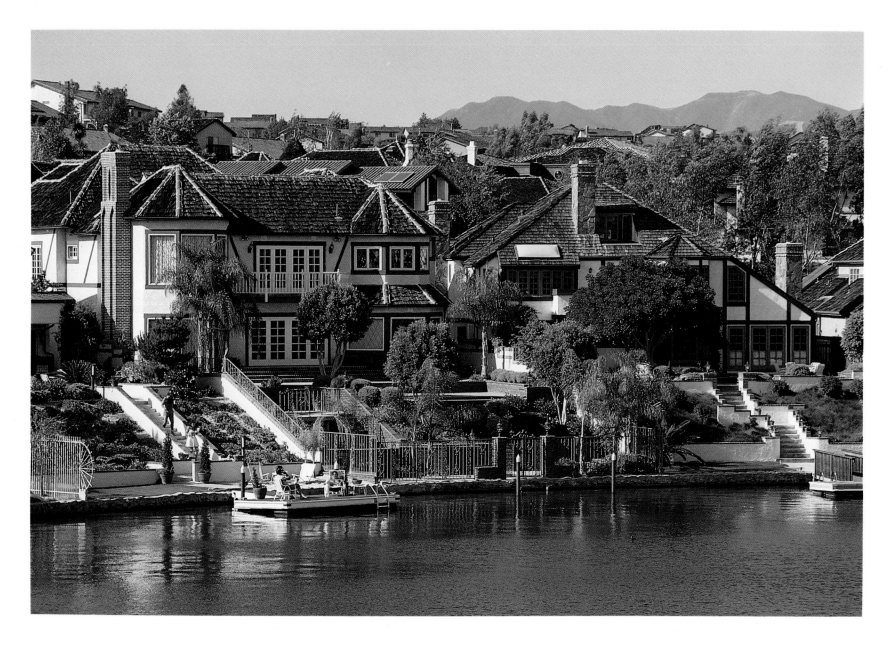

74-75 Sailing on the Lake, Mission Viejo, a new, fully-planned community of architect-designed homes begun in 1965, that has developed into a town of its own with over 55,000 residents by the early 80s and a strong sense of civic identity.

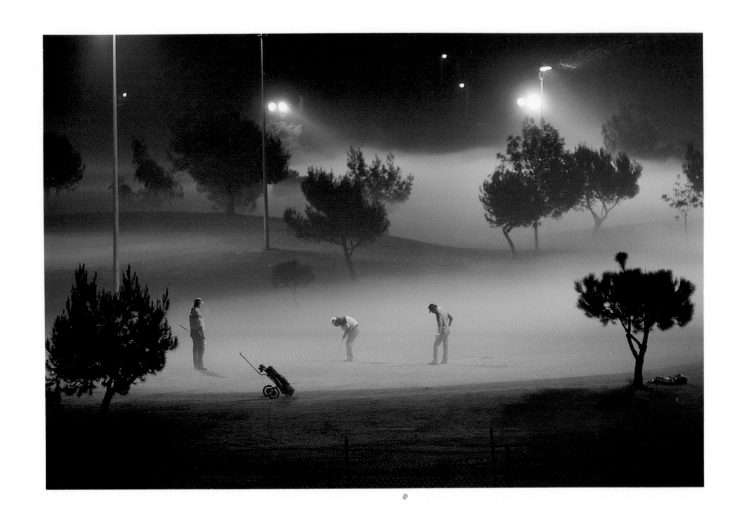

76 Night-game of golf, Newport Beach.

77 *(right)* California Angels baseball game in the 70,000 seat Anaheim Stadium.

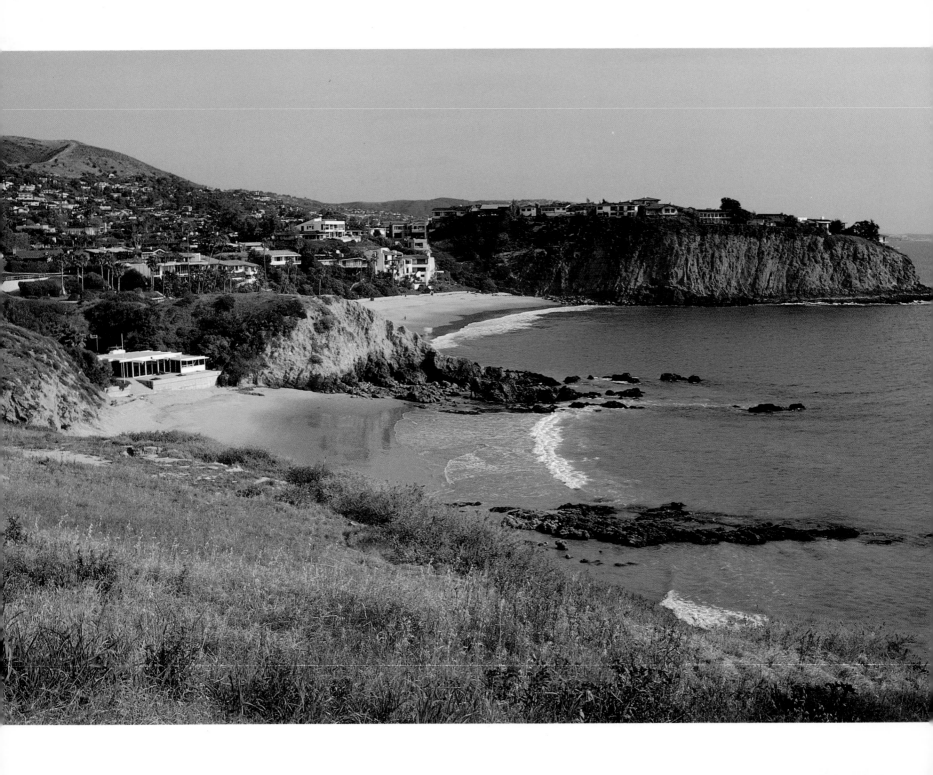

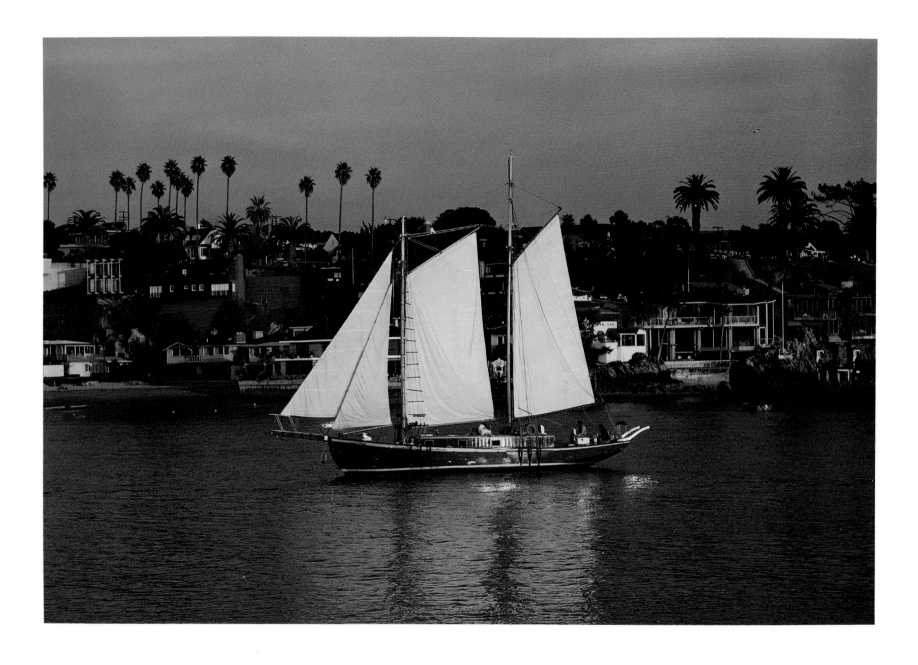

78 *(left)* Irvine Cove, just north of Laguna Beach.

79 Sailing on Balboa Bay, Newport Beach, with Corona del Mar in the background.

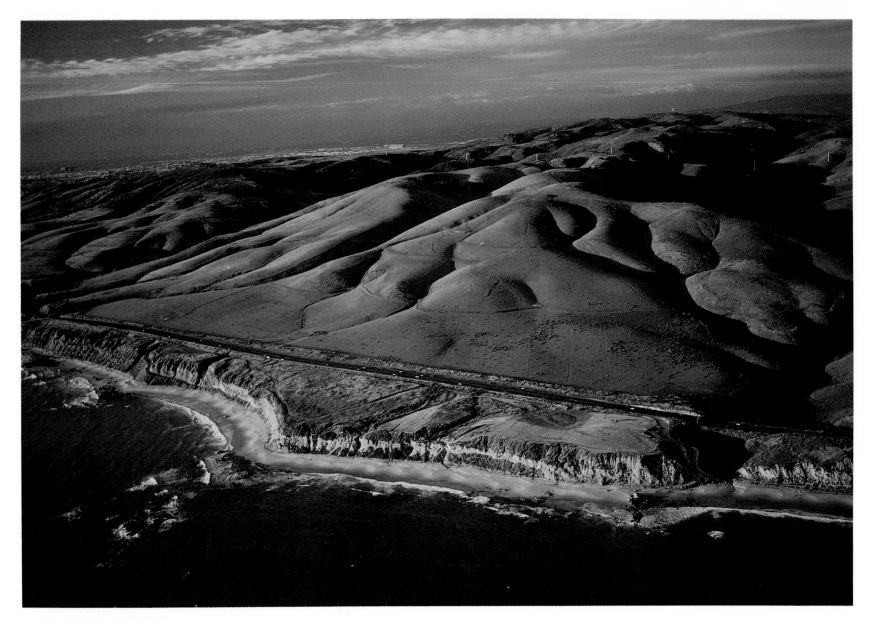

80 Coastline south of Corona del Mar, adjacent to Newport Beach, which
is known for its golf and tennis.

81 *(right)* Sunrise over Newport Center, showplace and headquarters of
the Irvine Company (see Plate 22).

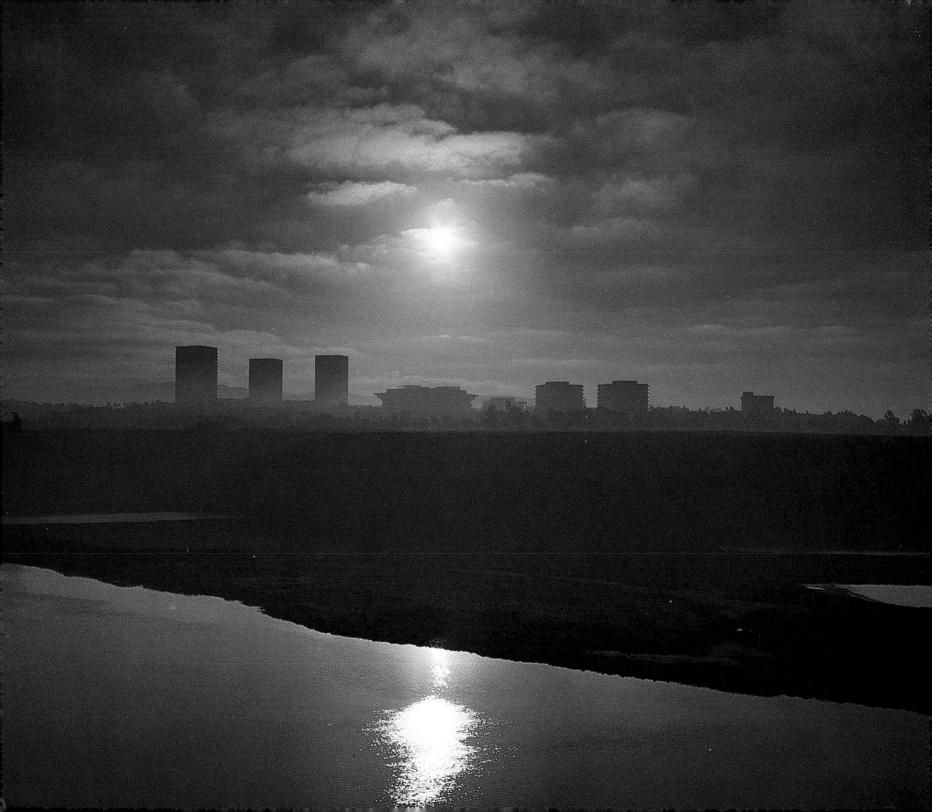

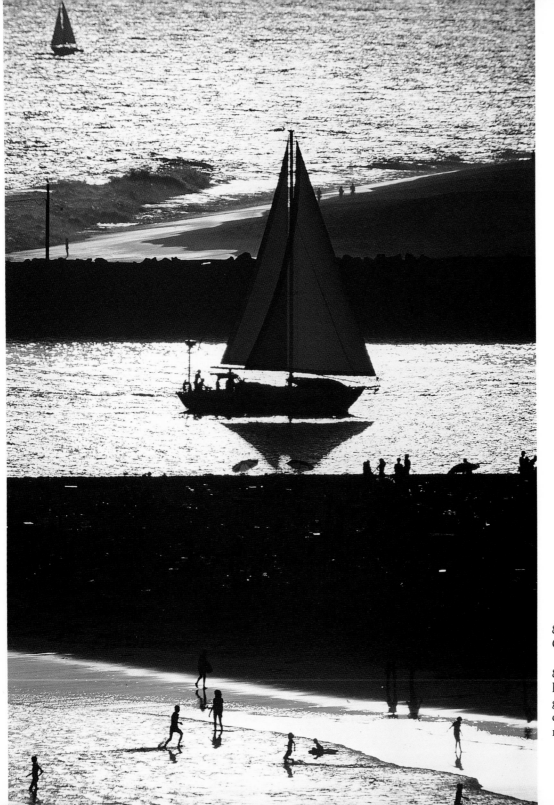

82 Newport Channel looking south from Corona del Mar.

83 *(right)* Balboa Pavilion; originally a bathhouse, this antique, cupola-topped extravaganza has been a landmark for nearly a century, echoing the grand style of Victorian resorts in Southern California.

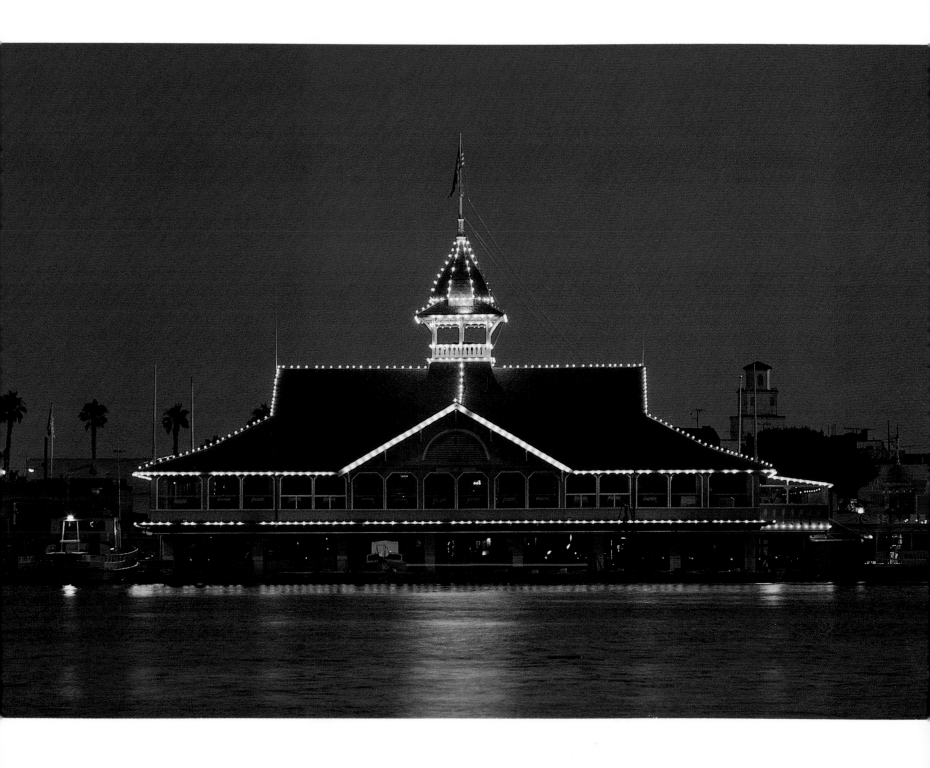

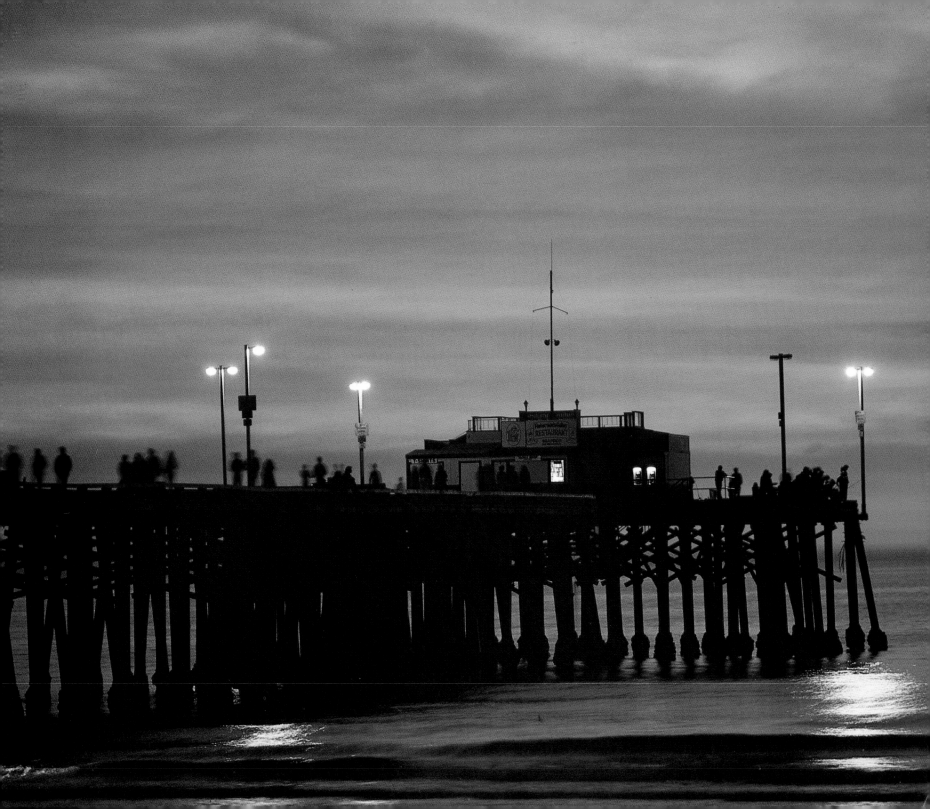

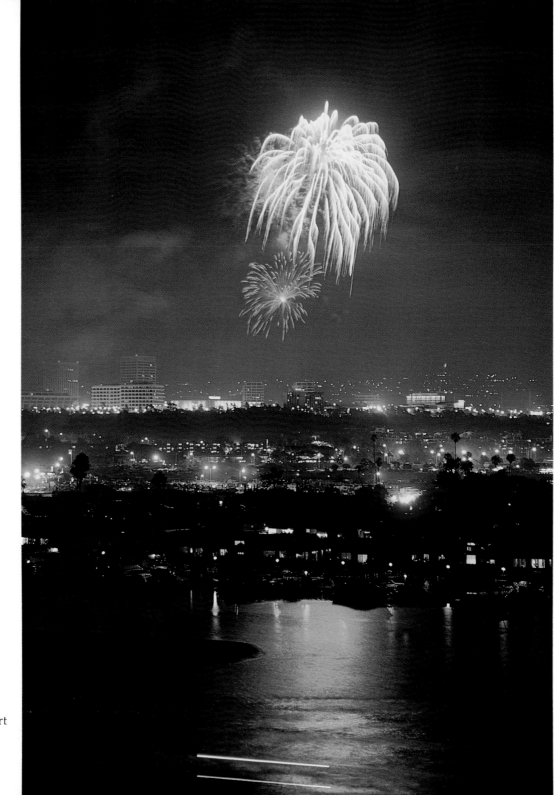

84 *(left)* Newport Pier at sunset.

85 Fourth of July fireworks over Newport Center.

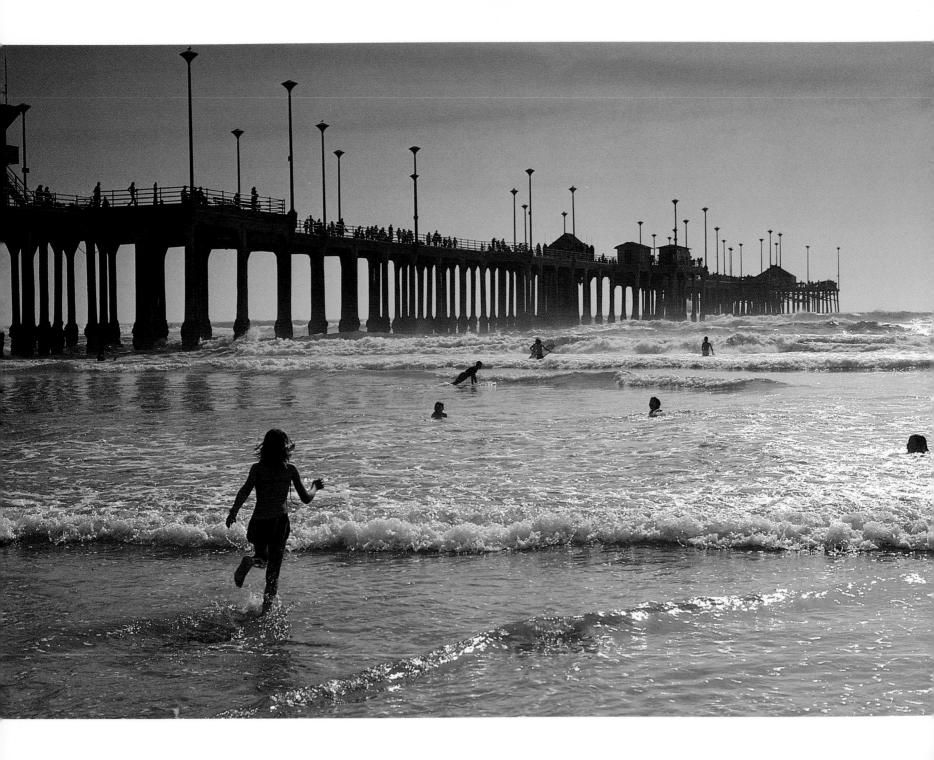

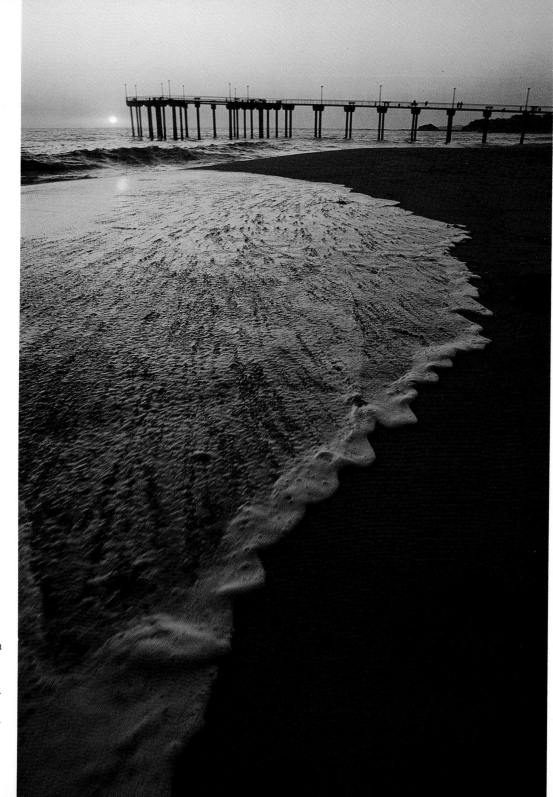

86 *(left)* Late afternoon, Huntington Beach Pier (see plate 59).

87 Aliso Beach, Laguna Beach (see plate 25).

88 *(overleaf)* Sunset from Corona del Mar, looking south.

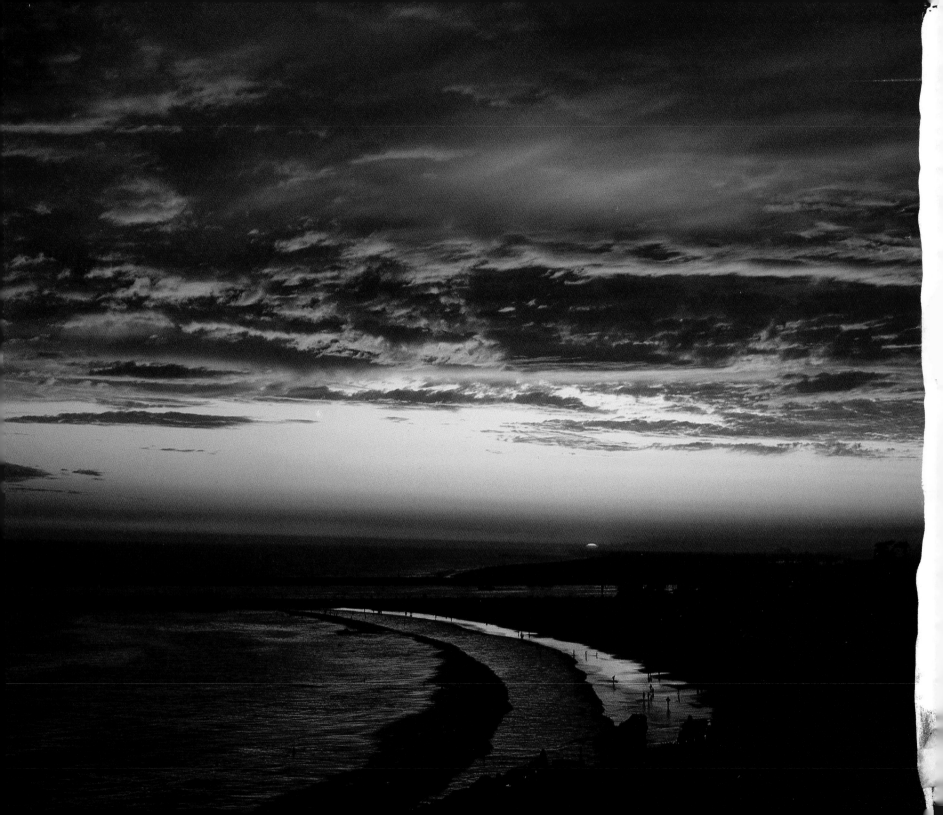